IMAGES
of Rail

RAILROADS OF
RENSSELAER

On the cover: Boston and Albany mail and express train 90 blasts through Rensselaer yard on its Troy-Boston run. Two Boston and Albany 600 series Hudsons provide the spectacular power on this winter day in 1953. The tracks at middle left lead to Albany Union Station. (Courtesy of Dick Barrett.)

IMAGES
of Rail

RAILROADS OF RENSSELAER

Ernie Mann

ARCADIA
PUBLISHING

Published by Arcadia Publishing
Charleston, South Carolina

Printed in the United States of America

Library of Congress Control Number: 2008942607

For all general information contact Arcadia Publishing at:
Telephone 843-853-2070
Fax 843-853-0044
E-mail sales@arcadiapublishing.com
For customer service and orders:
Toll-Free 1-888-313-2665

Visit us on the Internet at www.arcadiapublishing.com

*To the men and women who, over 165 years,
kept and still keep the trains of Rensselaer running.*

CONTENTS

Acknowledgments 6

Introduction 7

1. The Early Years 11

2. The Vibrant Decades 31

3. Decline and Disuse 61

4. Rebirth and Rejuvenation 87

ACKNOWLEDGMENTS

The author wishes to extend heartfelt thanks to the following who helped make this effort possible: Charles L. Ballard, Dick Barrett, Tom Bridgeford, Steve Brown, Gerrit Bruins, Phil Erlich, Margaret Farrell, Ed Fernau (Alco Historic Photos), Len Kilian, Steve Lackmann, Michael Mann, Edward L. May, New York Central System Historical Society, Janice Presti, Bill Schilling, Charles Semowich (Rensselaer City Historian), Jim Shaughnessy, Union Pacific Railroad Museum, Wayne Warden, and Jim Whitbeck.

INTRODUCTION

Rensselaer, New York, and the surrounding Capital District is an area that was a natural birthplace for transportation routes. The Hudson, Mohawk, and Champlain Valleys encouraged travel to the south, west, and north. The gradual slopes, passes, and river valleys of the Berkshires made eastward passage to the Atlantic Ocean achievable also. Routes originally marked by Native American trails became roads, canals, highways, and railroads. In later years, the Albany area was touted by the Vanderbilt system—the New York Central Railroad and its lessee, the Boston and Albany Railroad—as the "Albany Gateway," a busy portal to many destinations. Rensselaer could legitimately be called the threshold of that gateway.

From 1841 when the Albany and West Stockbridge Railroad came over the Berkshires and into Greenbush (now Rensselaer) to the fast and powerful Amtrak diesels of today, Rensselaer and its predecessor villages have witnessed a vast array of trains and rail activity. The next local line to emerge was the Troy and Greenbush Railroad, which ran north to the burgeoning industrial city of Troy, beginning in 1845. By 1851, the Hudson River Railroad had completed the rail line to New York. East Albany and Greenbush in the next decade saw the construction of roundhouses, freight houses, docks, wharves, coaling towers, machine shops, car repair facilities, and the like.

From these early years to current times, Rensselaer's strategic location has facilitated the passage of a myriad of notable and important trains. In 1861, the inaugural train of U.S. president elect Abraham Lincoln made its way down from Troy and passed through Bath-on-the-Hudson, East Albany, and Greenbush—the villages that later evolved into Rensselaer—on its way to New York. Four years later, what was unquestionably the most famous train ever to visit made its arrival around 11:00 p.m. on April 25, 1865. Abraham Lincoln's funeral train was making the long, somber trip from Washington, D.C., to Springfield, Illinois. Historians tell us that huge crowds filled the Greenbush-East Albany railyard. Village church bells and cannon salutes from the heights to the east added to the solemnity. The Hudson River Railroad had put over 600 workers on overtime from New York to East Albany to ensure the seamless operation of this train.

Many other notable trains stopped or passed through in later decades, especially during the four terms of Franklin Delano Roosevelt. Not only his frequent presidential specials, but trains carrying Prime Minister Winston Churchill and even the king and queen of England in 1939, passed through Rensselaer. Some 30 years later, crowds witnessed a service stop for the *Golden Spike Special*, which commemorated the completion of the transcontinental railroad. The cross-country train of the popular television show *Real People* drew an enthusiastic throng in

1983. The *Good Morning America* television show took the country's pre-election political pulse in 2008 with a special train, which had a long stop at Rensselaer, where the cast met the local folks on the platform.

Besides the prominent or glamorous specials, Rensselaer was notable for its sustained service to some of the most celebrated regular trains of the New York Central Railroad's "Great Steel Fleet." Locomotives that hauled the *Empire State Express, Commodore Vanderbilt, New England States,* and the greatest of all, the *20th Century Limited* were routine visitors to Rensselaer's engine house.

From the earliest years to the present time, Rensselaer became and remained a railroad town for a century. In between these chronological parameters, American railroads expanded, helped win several wars, weathered times of prosperity and depression, and were centers of much of the activities of the labor movement. The size, scope, influence, and importance of the railroads at their height is difficult to imagine for most citizens today. As in all railroad towns, the specter of the industry was pervasive and never out of sight. Walking down any local street in the first half of the 20th century, one would pass house after house where engineers, firemen, conductors, brakemen, timekeepers, clerks, towermen, machinists, and others lived. These, in most cases, were steady, comparatively well-paying jobs. Their existence added to the vibrancy and prosperity of the city in many ways. Railroaders and their families patronized and supported local grocery, hardware, clothing, appliance, tavern, and restaurant establishments. They became pillars of churches, fraternal organizations, veteran's posts, labor lodges, volunteer firehouses, and political parties. So important was the presence of the railroad that the city council for decades had a railroad committee, as it had for other crucial concerns such as public safety, streets, and schools. Most resident railroaders worked for the New York Central Railroad or the Boston and Albany Railroad, fewer for the Delaware and Hudson Railroad.

The good years of nationwide rail fortunes were graphically reflected in the good fortune of railroad towns, such as Rensselaer. This was clearly revealed in the peak years from 1890 to World War I. Rail employment grew exponentially with expanding rail business. Rensselaer yard was jammed with freight cars being marshaled for delivery to local industries or further travel over the Hudson, Mohawk, or Boston and Albany railroad lines. The roundhouse serviced the fast passenger engines as well as heavy freight locomotives for over-the-road service. For 24 hours a day, these and engines for local freights and Albany-Troy Beltline service were sent "out on the road."

The New York Central Railroad had long suffered the choking congestion of frequent, long freights rolling through the Albany area. In 1924, the company completed an enormous construction project to alleviate this condition. The Hudson River Connecting Railroad was built to divert main-line freights southwest of the Albany-Rensselaer area on a route from Hoffman's, New York, on the Mohawk River to Stuyvesant, New York, on the Hudson River. The major features of the immense project were 28 miles of double track railroad, construction of Selkirk yard, and the soaring railroad bridge over the Hudson River near Castleton. Although the "Castleton Cut-Off" solved the company's great congestion problems, it was a serious blow to Rensselaer. Freight trains were now worked at Selkirk. Rensselaer yard was no longer full of boxcars and with them went the local jobs of brakemen, car-checkers, yard clerks, and such, that previous freight business nourished. The situation was exacerbated a few years later by the onset of the Great Depression. Passenger and freight business declined in local areas as it did across the country.

It took World War II to provide some rejuvenation for the rail industry. Trains hauling troops, vital armament, and other war materiel soon put a strain on shop forces everywhere to keep them rolling. For the duration of the war and a few years after, the relative optimism of the times was expressed by the railroads in new streamlined passenger equipment and high expectations for the future. This optimism was to be short-lived however. The general postwar prosperity enabled more families to purchase new cars, and automobile ownership grew exponentially. At the same time, new highways were being planned and older ones improved, including the beginnings of

the Interstate Highway System. The combination of these factors caused a precipitous decline in both freight and passenger business. More cars, cheap gas, and federally subsidized roads caused boom times in the trucking and highway tourism industries. The railroads were unable to stand up to this new competition.

At the same time, the railroads, forced to try to make their operation more efficient, were rapidly converting motive power from steam to diesel-electric. Almost overnight, towns like Rensselaer saw their roundhouses and shop buildings demolished; within a few years, freight houses, yard offices, and signal interlocking towers followed suit. The good jobs, which contributed so much of the city's life, went with them. With diesels, no longer did the company need the roundhouse and coaling tower, nor did it need the pipe fitters, plumbers, machinists, hostlers, boilermakers, and laborers who worked there. Through the 1950s, five interlocking towers operated in Rensselaer all "three tricks" (24 hours) each day. From Tower 98 at Second Avenue to Tower D at the east end of the Livingston Avenue Bridge, the lever men in these towers controlled a complicated maze of signals and switches. Within a few years, improved signal systems made the buildings and the jobs redundant. The same held true for car repairmen when local and then long-distance passenger trains began to be eliminated.

By the early 1960s, Rensselaer yard was indeed a depressing sight. Large areas once covered with tracks were now covered by grass. The main lines from New York and Boston still saw reasonable use, but most other tracks had been pulled up. By the end of that decade, the railroad, as a national icon industry, looked bleak and the country had a bad case of what songwriter Steve Goodman called "the disappearin' railroad blues." In 1968, the classic Albany Union Station was closed and a small new station was built in Rensselaer. This "new, modern station," as Penn Central's public notices called it, was in actuality a dramatic example of how much passenger business had declined. Although it had become tired-looking, Albany's station was an innately beautiful reminder of what it had once meant to ride great trains. The new structure was utilitarian and unattractive, symbolic of how passenger trains were viewed at the time.

Around 1970, a series of factors began to emerge, which had the effect of beginning a reversal of the railroad malaise. A combination of choking highway traffic, recognition of the resulting pollution, and gasoline shortages seemed to remind the public and politicians alike that passenger and freight trains might indeed have a place in the scheme of things. Most of the railroads did not wish to get back into the passenger business, having fought for years for permission to get rid of these trains. Their position was understandable due to the mounting losses they had experienced.

The creation of the National Railroad Passenger Corporation (Amtrak) in 1971 was the government's attempt to solve the problem of how to eliminate many of these trains while insuring a basic and strategically needed system of passenger service. Many observers, including politicians, industry leaders, and advocacy groups, did not give Amtrak much of a chance to succeed. Early operations were hampered by the near-junk quality of many locomotives and cars inherited from the individual railroads. These could be seen daily in operation at Rensselaer.

Amtrak soon realized that it needed better equipment, built to its own specifications. This need resulted in Rensselaer once again achieving rail prominence. In 1976, Amtrak built a large state-of-the-art maintenance facility on land once occupied by the Boston and Albany Railroad roundhouse and the New York Central Railroad "Sand Lot" coach yard. The new complex included several structures as well as service and storage tracks. The primary purpose of this project was initially the maintenance of the new Rohr Turboliners, which raced across New York State each day at speeds up to 110 miles per hour. The only train sets of this type anywhere, were those based at Rensselaer and used on the Empire Corridor. In later years, F-40s, FL-9s, and Genesis units would receive regular servicing at the Rensselaer shop.

Once again, Rensselaer mirrored the national trend of railroad fortunes, just as it had done when railroads peaked around World War I and declined after World War II. The rail rebound continued when Amtrak built a new and larger Rensselaer station in the early 1980s, due to greatly increased ridership. The third and current station is one of the largest built in the country

in decades and is generally rated the 10th busiest, catering to approximately 775,000 passengers annually. Massive locomotives with horsepower ratings that could not be imagined a century ago are routinely serviced at Amtrak's Rensselaer shop.

These factors insure that at least to some degree Rensselaer is still a railroad town, and that for the foreseeable future, the trains of Rensselaer will continue to run.

One

THE EARLY YEARS

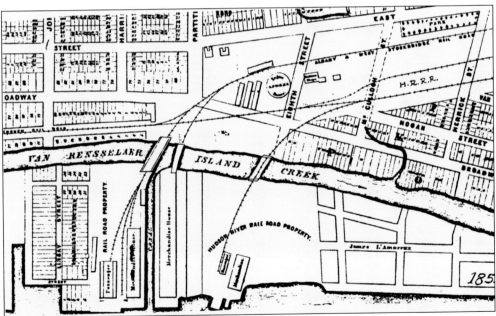

This map dates back to 1855. The riverside facilities of the Albany and West Stockbridge Railroad (later the Boston and Albany) and the Hudson River Railroad can be seen. The Troy and Greenbush Railroad line is shown on the left, between Broadway and the Van Rensselaer Island Creek, which was later filled in. There would be no railroad bridge to Albany for another 11 years. (Author's collection.)

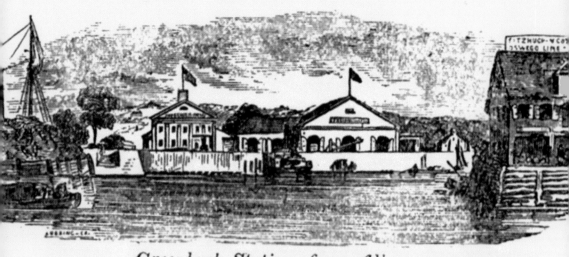

Greenbush Station, from Albany.

This is the earliest known view of a station at Greenbush (later Rensselaer). It was featured in a Hudson River Railroad tourist guide of 1851. The guide cited the "Extensive depot accommodations" and the "vast business in freighting" in predicting that the village would be a "very important point." In regard to rail traffic, this prophecy was to be proven true. (Author's collection.)

AN ACT

TO

INCORPORATE

THE

TROY AND GREENBUSH

RAILROAD

ASSOCIATION.

PASSED MAY 14, 1845,

BY A TWO-THIRD VOTE.

TROY:
PRINTED AT THE BUDGET OFFICE,
1845

The Troy and Greenbush Railroad was incorporated by this act of the New York State legislature in 1845 and was soon in operation. Trains to New York would not run until 1851. It was leased to the Hudson River Railroad in that year, when tracks to New York had been completed. This road, although wholly under the control of the Hudson River Railroad and the successor companies, remained as an "on paper" entity into the 1980s. The Troy and Greenbush Railroad is still used by two railroads today and sees almost daily service. (Author's collection.)

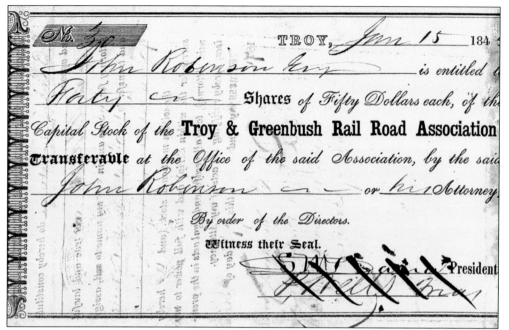

The Troy and Greenbush Rail Road was a six-mile line opened in 1845. There are no known extant images of its locomotives. This stock certificate, issued that first year, is one of only a handful of memorabilia items existing from this road. (Author's collection.)

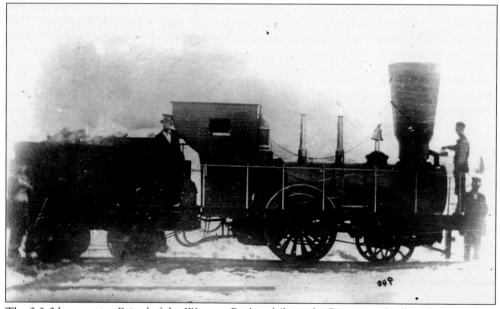

The 2-2-0 locomotive *Bristol* of the Western Railroad (later the Boston and Albany) was built by the Locks and Canals Company of Lowell, Massachusetts, in 1841. This locomotive would have been a frequent visitor to the East Albany shops and yard. Photographs of these engines, typical of the 1820s, are very rare. (Author's collection.)

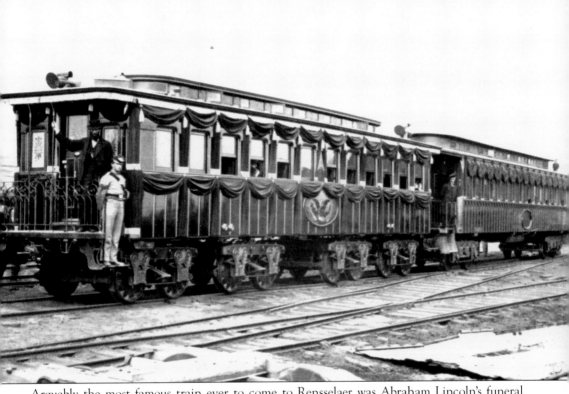

Arguably the most famous train ever to come to Rensselaer was Abraham Lincoln's funeral train. This car, described as a "deep chocolate" color, had been built for the president and other officials during the war. It was converted to carry Lincoln's casket from Washington, D.C., to Springfield, Illinois. The Hudson River Railroad's locomotive *Union* pulled the somber train into East Albany at approximately 11:00 p.m. on April 25, 1865, where it was greeted by church bells, cannon salutes, and huge crowds of grieving citizens. A ferry had to carry the president's remains across the Hudson River to Albany, as there was no railroad bridge (it was built the following year). The train was sent up the Troy and Greenbush Railroad line to Troy where a bridge did exist. The train went over and down to Albany where thousands passed the coffin at the New York State Capitol. Eventually the train resumed its westward journey. (Courtesy of Union Pacific Museum.)

FIRST RAILROAD BRIDGE OVER THE **HUDSON** AT **EAST ALBANY (RENSSELAER), 1866**

The first railroad bridge between Albany and East Albany (Rensselaer) was built in 1866, one year too late to carry Lincoln's funeral train. It was erected on the site of the Livingston Avenue Bridge, and many of the original piers are still in use on the current bridge. In 1873, much of the wood structure was replaced with iron. (Drawing by Ernie Mann; courtesy of Fraser Associates.)

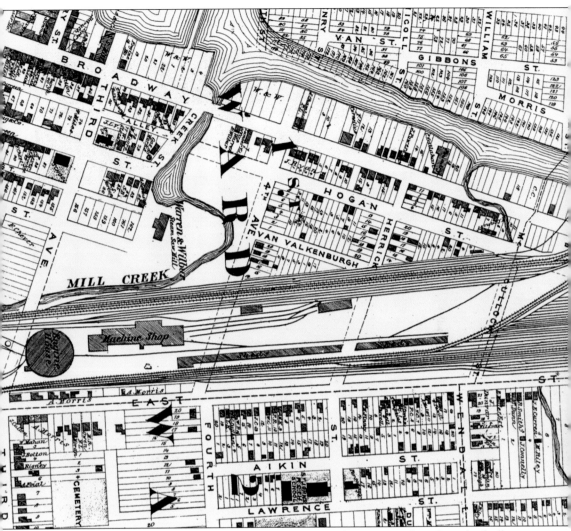

This map from Beers' atlas of 1876 shows the layout of the main yard at Greenbush (later Rensselaer). The roundhouse and machine shop of the New York Central and Hudson River Railroad are shown in the lower third of the map. The tracks for the Boston and Albany are above. (Author's collection.)

Shown here is the Boston and Albany mainline looking southeast as it passes under Columbia Turnpike. This view gives no hint of the controversy connected to the site in the 1870s when it was a grade crossing and the scene of many horrible accidents. The public's anger finally caused legislation to create the overpass. (Photograph by Ernie Mann.)

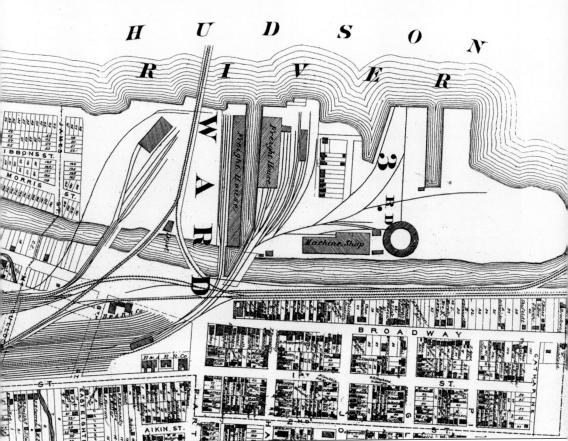

This map, from the Beers' atlas of 1876, shows the riverside complex of the Boston and Albany. The long, narrow building in the center, labeled "Freight House," dated from 1845 and survived into the late 1960s. (Author's collection.)

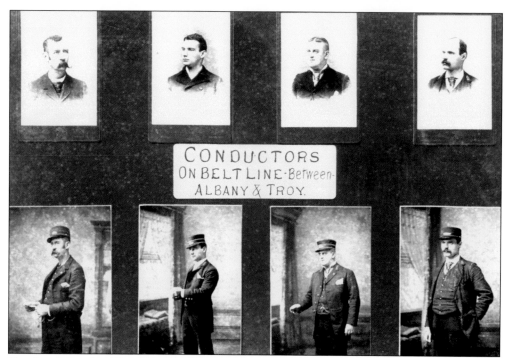

Conductors on the Albany-Troy Beltline had their civilian and uniformed portraits taken around 1900. Their names are lost to history but the two on the outside are Delaware and Hudson men, the two in the middle are from the New York Central. Rensselaer had two of the beltline stations. (Author's collection.)

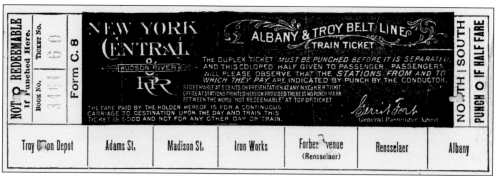

This ticket was punched around 1900 for a commuter travelling from Forbes Avenue Station to Troy Union Depot. (Author's collection.)

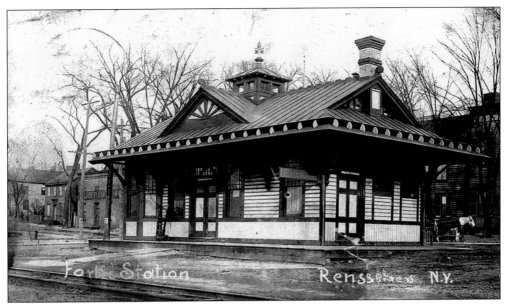

The New York Central and Hudson River had an attractively ornate station at Forbes Avenue in Rensselaer. This station served the Albany-Troy Beltline commuter trains, which in conjunction with the Delaware and Hudson Railroad, ran every half hour. (Author's collection.)

Stephen C. Mann was a machinist for 43 years on the Boston and Albany, spending his entire career at the East Albany (later Rensselaer) shop. (Author's collection.)

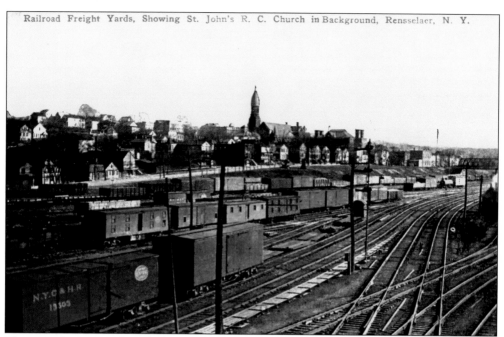

Railroad Freight Yards, Showing St. John's R. C. Church in Background, Rensselaer, N. Y.

This view from around 1905 of Rensselaer yard gives clues as to the scope of rail business here. Looking southeast from the Broadway Viaduct, tracks can be seen all the way to East Street. The two parallel tracks seen going away at the lower right are the Boston and Albany main lines. Those in the lower right corner are the New York Central and Hudson River Railroad main lines to New York City. (Author's collection.)

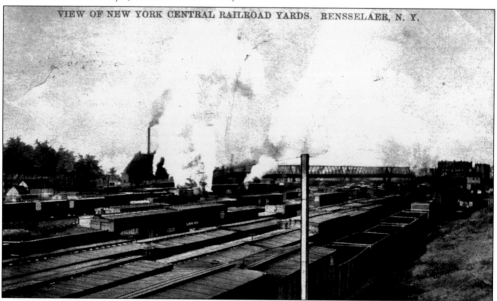

VIEW OF NEW YORK CENTRAL RAILROAD YARDS. RENSSELAER, N. Y.

The first decade of the 20th century was a period of high-volume rail freight in Rensselaer. This view looks northwest across the yard from the Boston and Albany side. The same view after 1924 would be much different. The completion that year of the Castleton Cut-Off took most main line freight traffic out of Albany and Rensselaer and detoured it across the Hudson River several miles south. (Author's collection.)

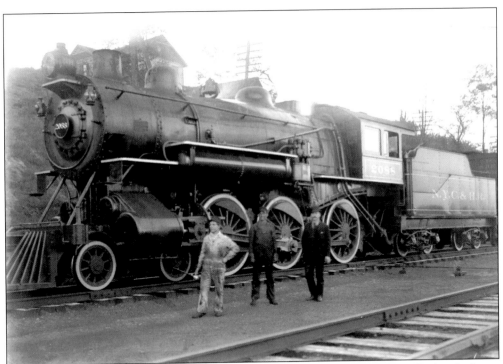

The 2088 was a class F-2 10-wheeler of the New York Central and Hudson River Railroads. It was built by Schenectady Locomotive Works in 1905. Her engineer, fireman, and freight conductor pose with the engine at Rensselaer, New York, around 1910.

The Hudson River Bridge Company (a subsidiary of the New York Central and Hudson River Railroad) built the second Maiden Lane Bridge in 1900. The pedestrian walkway on the north side of the bridge was used by Rensselaerites for over 60 years to walk over to downtown Albany. In the early days of the bridge, there was a fee of 1¢ for the privilege. (Author's collection.)

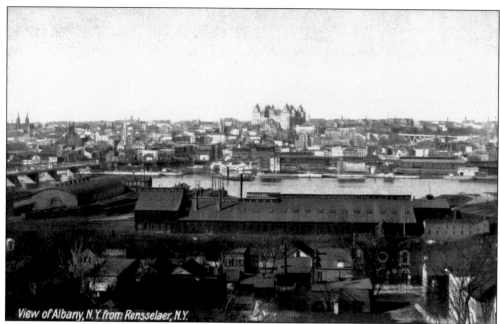

View of Albany, N.Y. from Rensselaer, N.Y.

The photograph used on this postcard was taken from the steeple of St. Paul's Lutheran Church on Third Street. Two prominent railroad buildings are shown. At the left, the flourhouse can be seen with the arched roof. This building was once the western terminus of the Boston and Albany. The long structure in the center is the Boston and Albany shop, where the author's grandfather worked as a machinist for 43 years. This view is from around 1900. (Author's collection.)

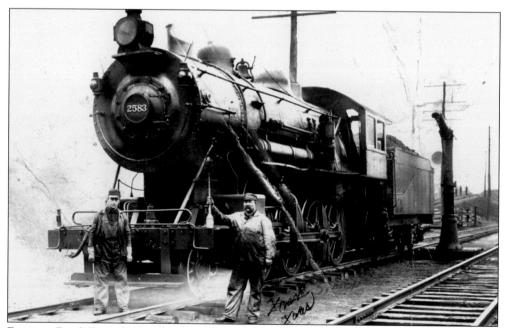

Engineer Frank Faas of Rensselaer proudly holds high his "long oiler," a classic tool of his calling. His engine was class G-34a 2-8-0 2583, built by Schenectady in 1903. This view dates to around 1910. (Author's collection.)

24

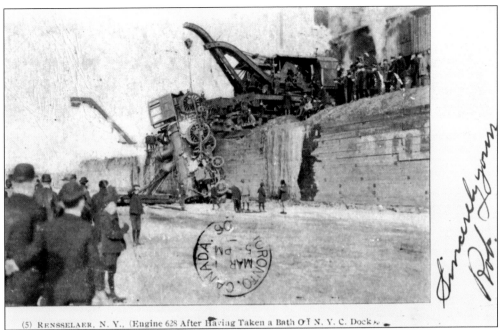

(5) RENSSELAER, N. Y., (Engine 628 After Having Taken a Bath OF N. Y. C. Dock

New York Central and Hudson River Railroad 4-4-0 American type 628 has plunged out of the rear wall of the Rensselaer roundhouse and landed nose-first on the frozen Hudson River. Also on the ice is a large crowd of observers, no doubt offering critical opinions of the operation. Over time, this type of accident occurred in many roundhouses across the country. The date is unknown but the card was mailed in 1906. (Author's collection.)

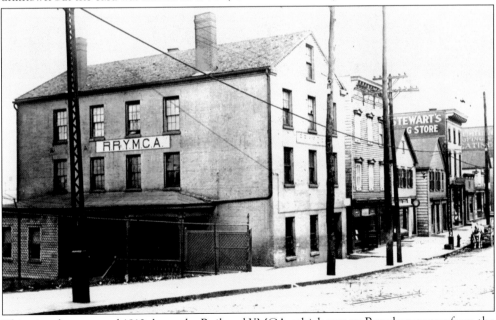

This view from around 1910 shows the Railroad YMCA, which was on Broadway across from the library. Train and engine crews who took trains to and from New York City, Springfield, Utica, and other places could find a clean bed, hot meal, and bathing facilities here between runs. These institutions were once common in railroad towns. (Author's collection.)

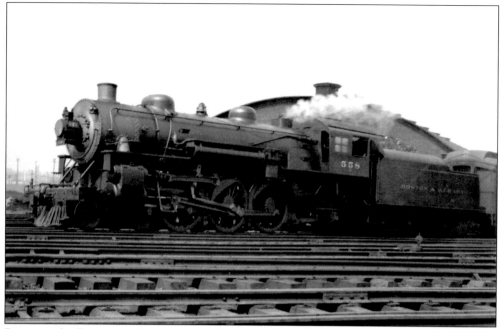

Boston and Albany class K1 Pacific No. 558 readies for a run over the mountain to Springfield, Massachusetts. The arched-roof building in the background is the flourhouse, which dated back to 1845. This scene is from August 1915. (Courtesy of NYCS Historical Society.)

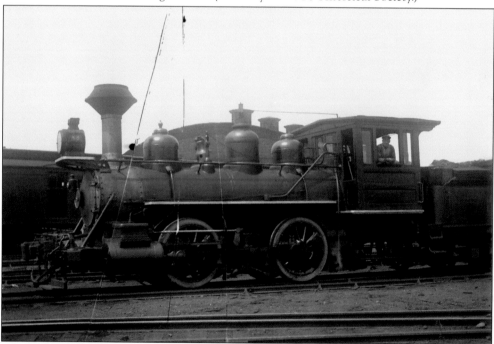

New York Central and Hudson River Railroad 0-4-0 switcher No. 89 is shown in Rensselaer yard on a July day in 1910. This very functional workhorse of an engine seems to project an unusual degree of elegance. The vertical lines in the picture are from cracks in the glass-plate negative. (Courtesy of NYCS Historical Society.)

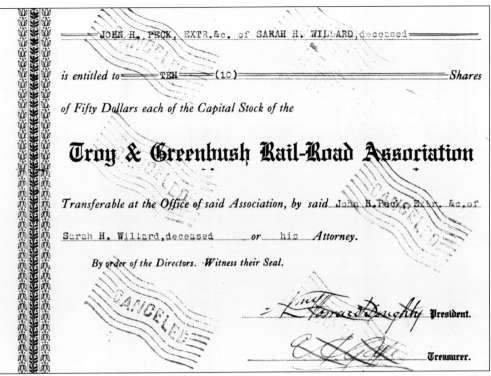

This newer style stock certificate was issued by the Troy and Greenbush Railroad in 1907. This tiny, local railroad, although run by the New York Central, existed on paper into the 1980s. (Author's collection.)

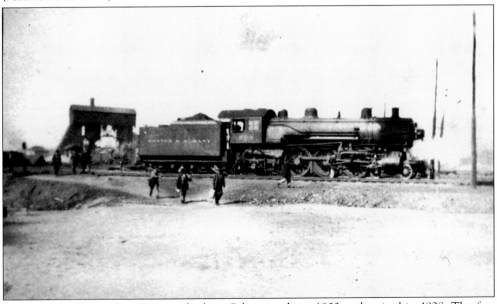

Boston and Albany class K-1a was built in Schenectady in 1903 and retired in 1928. The fast Pacific-type started life as the 2703, became the 3503, and received its final number in 1912. Among area rail historians, this is the only known photograph of the Boston and Albany's Rensselaer coaling facility. (Courtesy of Dick Barrett.)

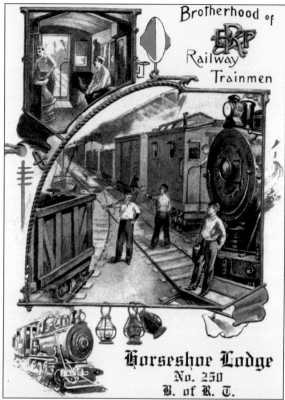

The annual ball of Rensselaer's Horseshoe Lodge of the Brotherhood of Railroad Trainmen was a major social event with dinner, music, and dancing. The program covers were beautifully illustrated and printed in embossed full color. By today's standards, they seem extremely ornate. This one is from the 1911 affair. (Author's collection.)

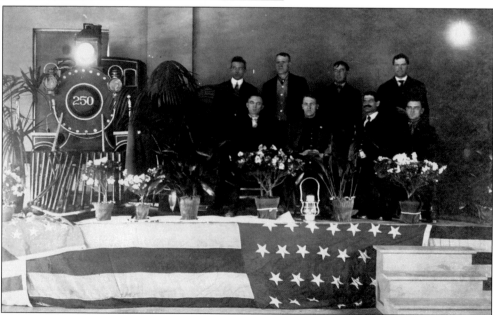

This 1914 view shows a gathering of the Horseshoe Lodge No. 250 of the Brotherhood of Railroad Trainmen. The festive occasion was held at Duff's Hotel, which was on the site of the present police station. The silver-plated presentation lantern suggests a retirement dinner, the trappings of which indicate the pride of the railroader's calling. (Author's collection.)

The New York Central station at Rensselaer served locals and Troy Beltline trains. The walkway and tracks in the foreground are leading to the Maiden Lane Bridge. The Broadway Viaduct is seen in the background of this *c.* 1920 scene. (Author's collection.)

Photographs of the actual Rensselaer roundhouse are not that plentiful due to the fact that it was obscured from view by the large coaling facility adjacent to it. In this view, the turntable and its operator cabins can clearly be seen. The towers of the Maiden Lane Bridge are seen in the distance. (Courtesy of Dick Barrett.)

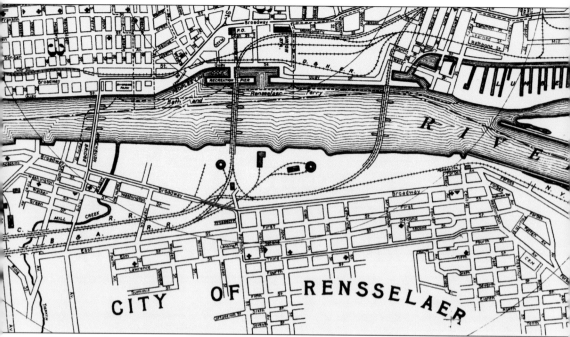

This map, dating to about 1915, shows the (approximate) locations of the New York Central and Hudson River and Boston and Albany's roundhouses. The proximity to Albany's Union Station (upper middle) is evident. (Author's collection.)

Two

THE VIBRANT DECADES

Critical rail locations including bridges were under armed guard during World War I. New York Central signal maintainers are seen here giving a ride to a soldier on the Livingston Avenue Bridge. C. E. Mann Sr. is in the center in this 1918 view. (Author's collection.)

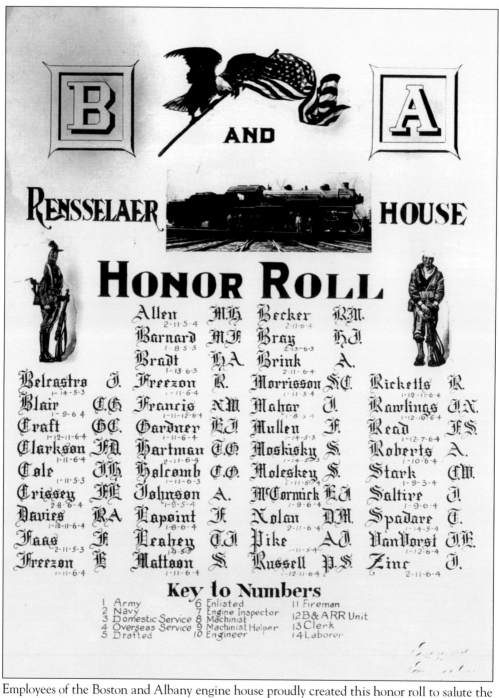

B AND A

RENSSELAER HOUSE

HONOR ROLL

Allen M.H. 2-11-5-4		Becker R.M. 2-11-6-4			
Barnard M.J. 1-8-5-3		Bray H.J. 2-13-6-3			
Bradt H.A. 1-13-6-3		Brink A. 2-11-6-4			
Belcastro J. 1-14-5-3	Freezon R. 1-11-6-4	Morrisson S.C. 1-11-5-4	Ricketts R. 1-12-11-6-4		
Blair E.G 1-9-6-4	Francis X.M 1-11-12-6-4	Mahar J. 1-8-3-4	Rawlings J.X. 1-12-10-6-4		
Craft G.C. 1-12-11-6-4	Gardner E.J 1-11-6-4	Mullen F. 1-14-5-3	Read F.S. 1-12-7-6-4		
Clarkson H.D. 1-11-6-4	Hartman T.G 2-11-6-4	Moskisky S. 1-14-5-3	Roberts A. 1-10-6-4		
Cole J.H. 1-11-5-3	Holcomb E.O. 1-11-6-3	Moleskey S. 1-11-6-4	Stark E.M. 1-9-3-4		
Crissey J.E 28-6-4	Johnson A. 1-9-5-4	McCormick E.J 1-9-6-4	Saltire J. 1-9-6-4		
Davies R.A 1-12-11-6-4	Lapoint F. 1-8-6-4	Nolan D.M. 2-11-6-4	Spadare T. 1-14-5-4		
Faas F. 2-11-5-3	Leahey T.J. 1-9-5-4	Pike A.J. 1-11-5-4	VanVorst J.E. 1-12-6-4		
Freezon E. 1-11-6-4	Mattson S. 1-11-6-4	Russell P.S. 1-12-11-6-4	Zinc J. 2-11-6-4		

Key to Numbers

1 Army	6 Enlisted	11 Fireman	
2 Navy	7 Engine Inspector	12 B & A RR Unit	
3 Domestic Service	8 Machinist	13 Clerk	
4 Overseas Service	9 Machinist Helper	14 Laborer	
5 Drafted	10 Engineer		

Employees of the Boston and Albany engine house proudly created this honor roll to salute the 42 workers from that facility that served in World War I. (Author's collection.)

In this c. 1925 view, a New York Central yard crew takes a break to pose for the photographer on the front of their class U-3b 0-8-0 switch engine. The locomotive was built by Lima in 1921. Newsboy caps were apparently in vogue at the time with these gentlemen. (Author's collection.)

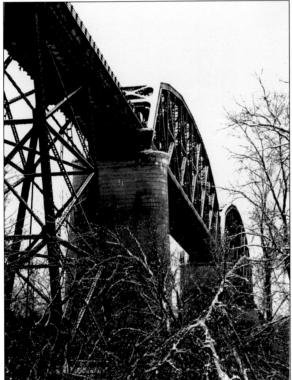

In 1924, the New York Central opened the Castleton Cut-Off, a massive project to reroute freight trains through Selkirk instead of running them through West Albany, Albany, and Rensselaer. The Alfred H. Smith Memorial Bridge at Castleton took away much of Rensselaer's freight business. This structure was named for a highly regarded former company president who was killed in an equestrian accident. (Photograph by Ernie Mann.)

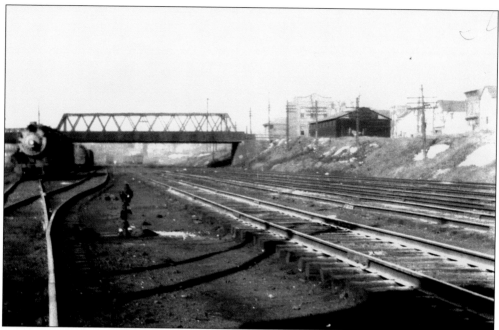

This view dates to around 1930. The east side yard in Rensselaer shows the effect of the recently-built Castleton Cut-Off, which diverted most freight traffic from West Albany and Rensselaer to Selkirk. Only a few years earlier, these tracks would have been virtually full of boxcars. (Author's collection.)

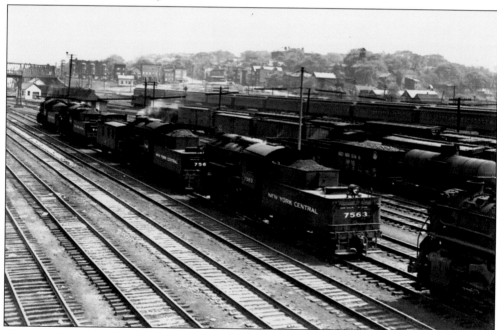

This view of the east side of Rensselaer yard dates to the mid-1930s. Several class U 0-8-0 switches are lined up for assignment. These locomotives were used in yard switching and as pushers on West Albany Hill. The string of coaches in the background is on the Boston and Albany tracks near East Street. (Author's collection.)

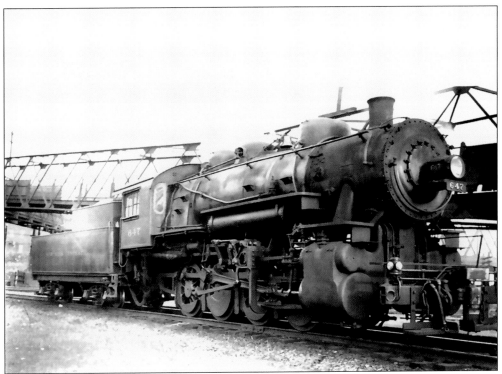

Burly New York Central class U-2d 0-8-0 647 pauses at Rensselaer in March 1936. The 647 was built in Schenectady by Alco in 1917. These workhorses performed many heavy switching duties for decades. These were also used as pushers on West Albany Hill. (Photograph by Edward L. May.)

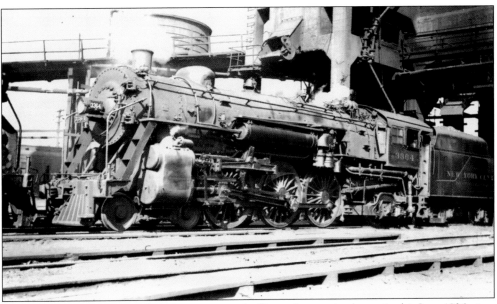

The classic lines of K-3g Pacific 3364 are seen at the Rensselaer engine house in this June 1936 view. This engine's number would be changed to 4854 within a year. (Photograph by Edward L. May.)

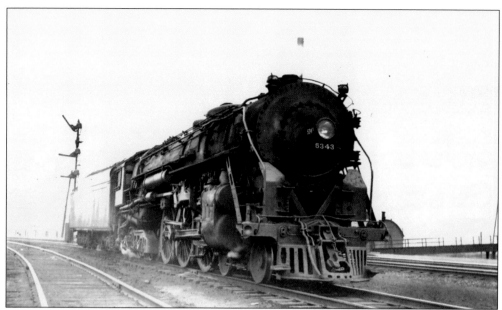

Class J-1e Hudson 5343 is ready to back over the Maiden Lane Bridge to pick up an eastbound train in Albany's Union Station. The date is March 22, 1936. (Photograph by Edward L. May.)

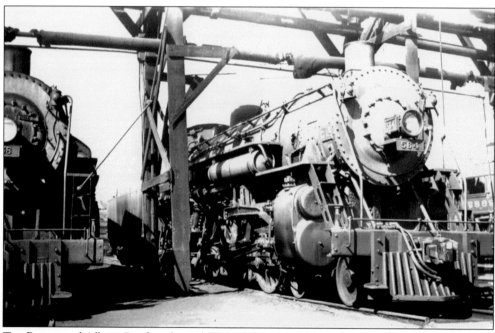

Two Boston and Albany Pacifics, class K-l 558 and class K-m 564 are shown at Rensselaer on June 28, 1936. Both engines are in for between-runs servicing. (Photograph by Edward L. May.)

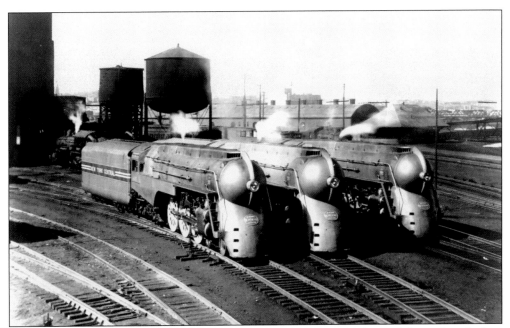

Three of the New York Central's new streamlined Hudsons pose in front of the coaling facility. These were designed by Henry Dreyfuss for the 1938 version of the *20th Century Limited*, called by many the "greatest train in the world." The long arched roof structure in the center of the photograph is the flourhouse, which dated to 1845. (Courtesy of Alco Historic Photos.)

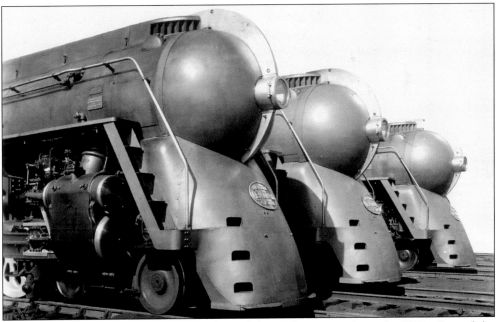

The streamlining craze in American industrial design hit its zenith in the 1930s. One of the most successful efforts was Dreyfuss's design for the *20th Century Limited*. Three of these beauties pose for an official company portrait at Rensselaer in 1938. (Courtesy of Alco Historic Photos.)

was out of adjustment the switch machine

24 June 11th 1939
Called to S.S 99 at 9.50 P.M.
Arrived at S.S 99 at 10.20 P.M.
Off duty at 11.45 P.M.
Account of 2 special Trains
from Hudson Division to Troy.

25 June 13th 1939

This cryptic entry in the overtime log book of C. E. Mann has historical significance. The "2 special trains" were a pilot (security) train and the royal train carrying King George VI and Queen Elizabeth of England from Hyde Park (where Franklin Delano Roosevelt fed them hot dogs) to Canada. Britain's hostilities with Germany caused a very elevated level of security. (Author's collection.)

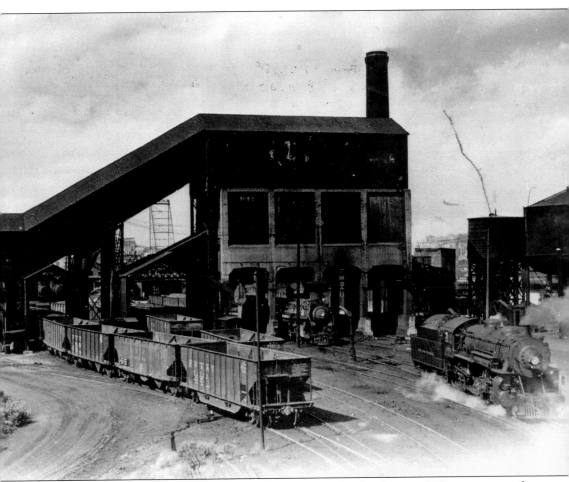

The Rensselaer engine facility was a non-stop operation. In this busy c. 1940 scene, one of the New York Central's venerable Pacifics is on the ready track with a Hudson soon to follow. The empty coal hoppers will soon be replaced with loads in an ongoing ritual. (Courtesy of Wayne Warden.)

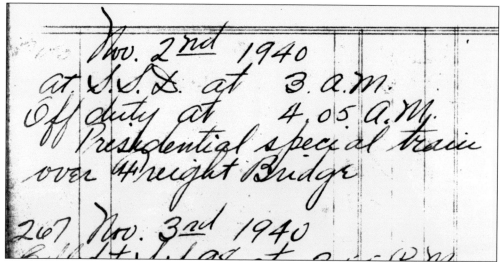

Nov. 2nd 1940
at S.S.D. at 3. a.m.
Off duty at 4.05 A.M.
Presidential special train
over 4 Freight Bridge

267 Nov. 3rd 1940

Pres. Franklin D. Roosevelt's special train passed through Tower D's plant in the early hours of November 2, 1940. He was making one last campaign trip from Hyde Park to Cleveland a few days before winning his third term. War clouds were darkening over Europe and Asia, and high security was the reason the author's father was called out on overtime to help insure the safe passage through Rensselaer yard. (Author's collection.)

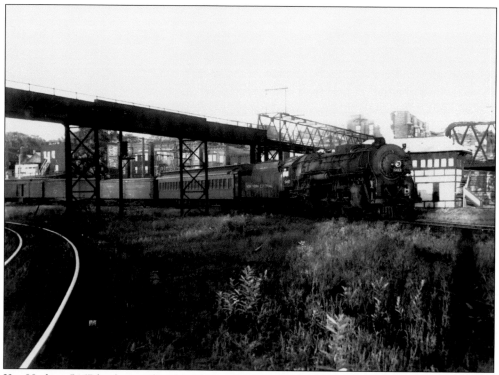

J3-a Hudson 5467 leads a mail and express train from Troy as it swings onto the approach to the Maiden Lane Bridge. Tower 100 is seen in the background of this view from the early 1940s. (Author's collection.)

This patch was worn on jackets by engine house employees during World War II, both as a source of pride in one's calling and also as another form of identification. (Author's collection.)

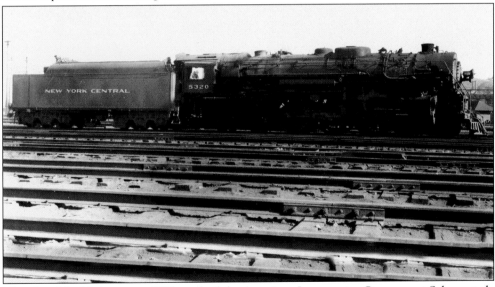

This class J-1e, Hudson-type 5320 was built by American Locomotive Company at Schenectady in 1931. Many rail enthusiasts and historians considered them to be the most beautiful of American steam power. In this view from around 1945 the engine has been freshly outshopped at Rensselaer's engine house and will soon back over the Maiden Lane Bridge and pick up its train at Albany's Union Station. (Author's collection.)

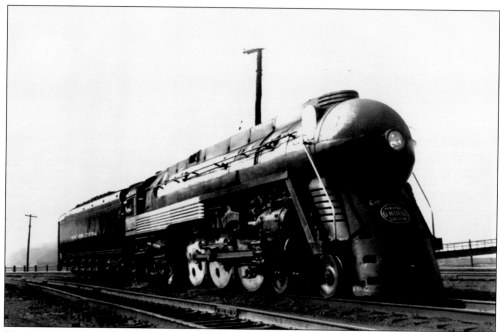

J-3a Hudson 5426 is at the Rensselaer engine facility in May 1946. The attractive streamlining was designed and applied for the *Empire State Express*. In one of the unluckiest business decisions of all time, the New York Central chose December 7, 1941, as the day the train would be introduced to the public and would hopefully receive great press coverage. History dictated otherwise. (Photograph by Edward L. May.)

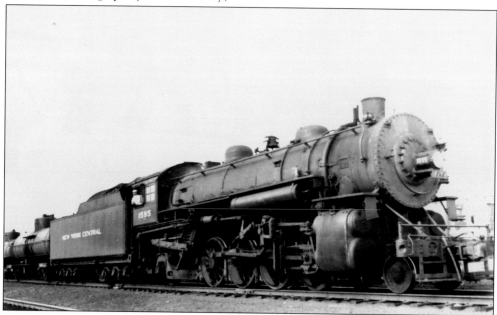

New York Central H5p 2-8-2 1595 pulls a local freight drag through Rensselaer yard in May 1946. These Mikado types were pushed to the limit on local and branchline jobs during World War II. Originally this engine was a 2-8-0 Consolidation type but was rebuilt by Brooks Locomotive Works during World War I. (Photograph by Edward L. May.)

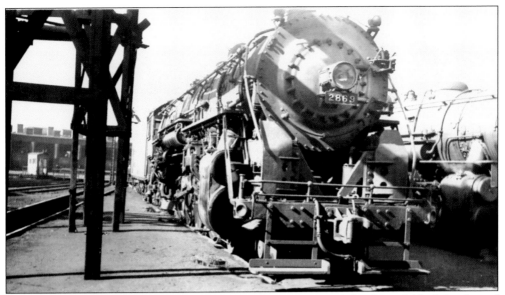

New York Central Mohawk 4-8-2 2869 was a representative of the dependable L-2c class of road freight locomotives. This engine has just emerged from the roundhouse and, after being replenished with coal, water, and sand, will be given yet another assignment. (Photograph by Edward L. May.)

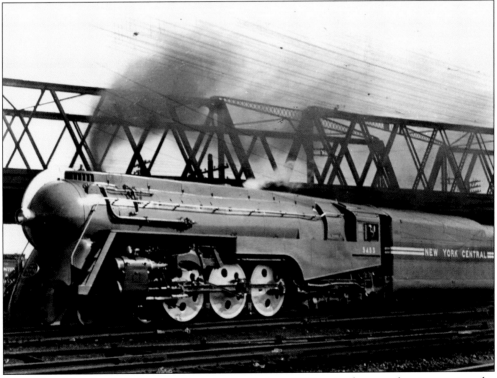

Streamlined for the *20th Century Limited*, J-3a Hudson 5453 waits for a road assignment under the Broadway Viaduct in this 1945 scene. The streamlining was removed from this engine in March 1947. (Author's collection.)

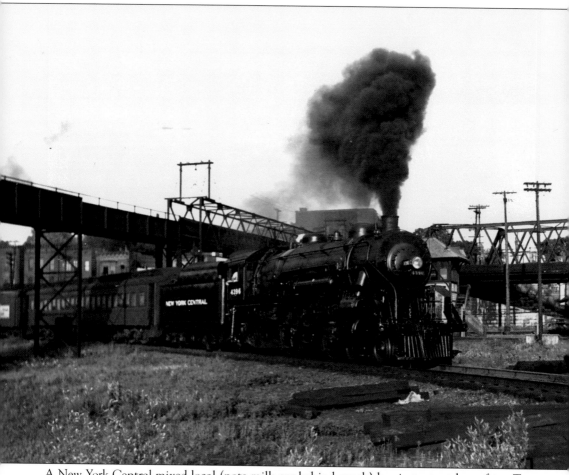

A New York Central mixed local (note milk car behind coach) has just come down from Troy and swings on the north leg of the wye, headed for the Maiden Lane Bridge. The power on this July 31, 1948, is class K-14f Pacific 4396. (Author's collection.)

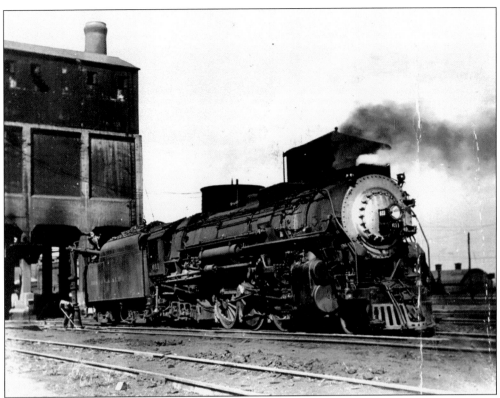

Boston and Albany class J-2c Hudson 611 is shown getting her tender's tank filled with water at the Rensselaer engine house in 1948. The 611 was built by Lima in 1931. (Author's collection.)

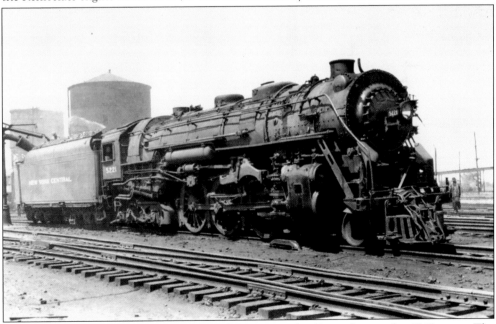

One of the beautiful J-1 Hudsons is shown being watered at Rensselaer in this 1949 scene. The 5221 was a 1927 product of Alco. (Photograph by Edward L. May.)

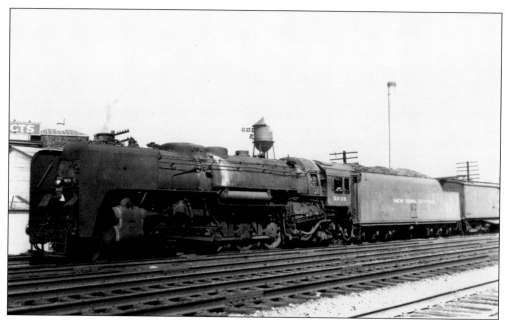

One of the burly L-3 Mohawks, 3085, heads out eastbound for New York with a mail and express train in August 1949. The locomotive is passing the Kenwood Mills complex. (Photograph by Edward L. May.)

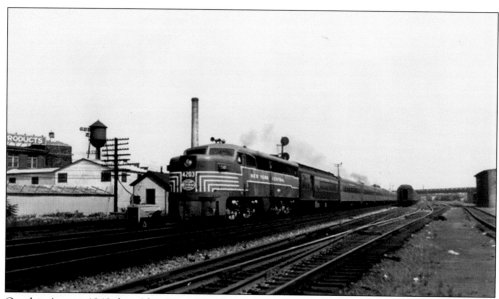

On this August 1949 day, Alco PA 4203 wheels train 138, the *Upstate Special*, through the yard, heading for Grand Central. (Author's collection.)

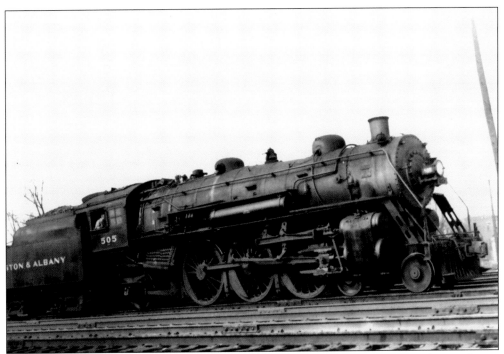

Class K-3n, Pacific type 505 was one of the Boston and Albany's passenger racehorses. It was built by Brooks Locomotive Works in 1918. It is seen here at Rensselaer in 1950. (Photograph by Edward L. May.)

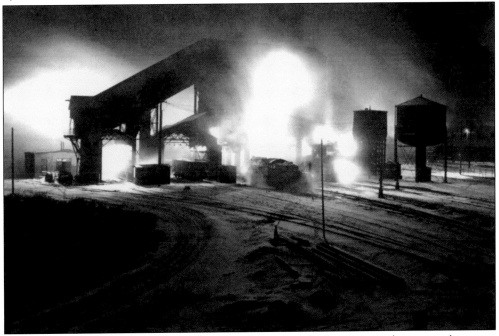

On a bitter cold winter night in 1950, the Rensselaer engine facility presented a spectacular scene. It is illustrative of the fact that the railroad was a 24 hour operation, regardless of conditions. (Courtesy of Dick Barrett.)

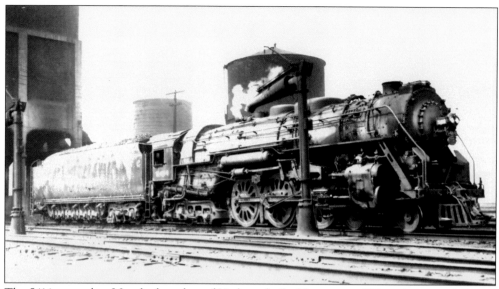

The 5414 was a class J-3a, the last class of Hudsons built. The massive PT tender carried 43 tons of coal and 17,500 gallons of water. This locomotive was photographed at Rensselaer on July 3, 1950. (Photograph by Edward L. May.)

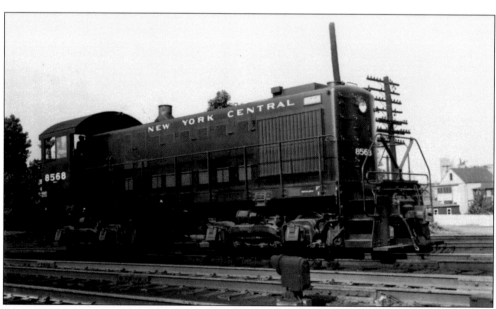

Alco-GE S-2 8568 was only three months old when it was photographed working the yard at Rensselaer in July 1950. (Photograph by Edward L. May.)

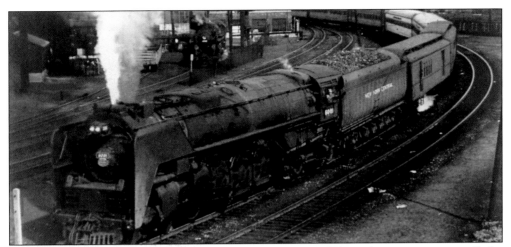

Class S-1b 6001, a 4-8-4 Niagara type, swings a New York–bound passenger train off the Maiden Lane Bridge toward the Hudson Division main. This view is from about 1950. (Author's collection.)

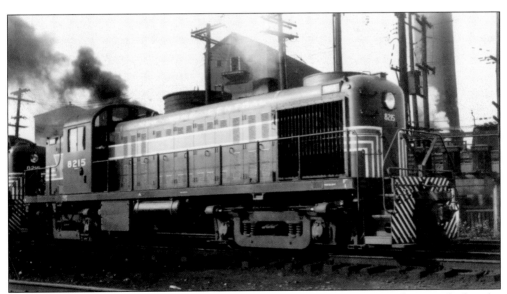

Diesel locomotives had made inroads by the time this passenger RS-2 was photographed at the Rensselaer engine facility. Time was running out for steam power (and for roundhouses like Rensselaer's). (Photograph by Edward L. May.)

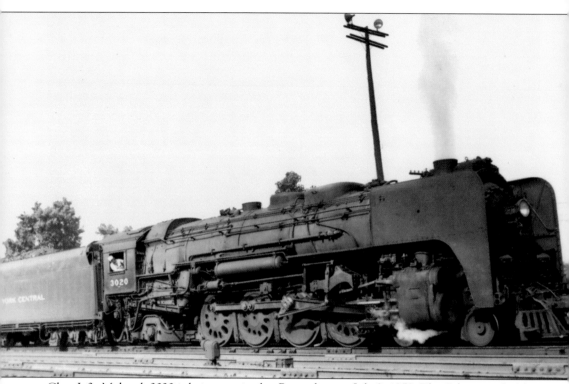

Class L-3a Mohawk 3020 is being serviced at Rensselaer on July 2, 1950. The Schenectady Alco product was 10 years old at this time. (Photograph by Edward L. May.)

This crew of Rensselaer roundhouse foremen took time to pose next to a brand-new Alco road switcher in 1950. Second from left is Joe Bellegarde who was also a longtime city alderman. Fourth from left is Bill Hardt, who was also Rensselaer's mayor. (Author's collection.)

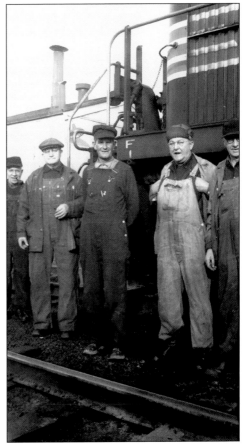

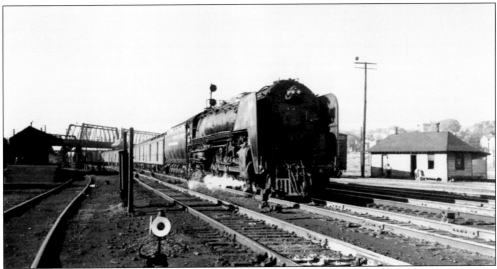

On a hot July day in 1950, Niagara-type 4-8-4 6010 thunders through Rensselaer with an eastbound mail and express train. The fast and powerful Niagaras were never really given a chance to prove their maximum potential due to the fast-evolving diesel revolution. (Author's collection.)

HUDSON RIVER RAILROAD CENTENNIAL
and
AUTUMN SCENIC TRIP
Via New York Central System
SATURDAY, SEPTEMBER 29th, 1951

Fare

Only $5.50

Round Trip
Incl. U. S. Tax
(Children of proper
ages half-fare)

•

Please Make Reservations As
Quickly As Possible As Reserva-
tions are limited.

Featuring

Hudson Valley in Autumn
Troy-Schenectady Freight Line
West Shore Freight Line
Selkirk Yards and Terminal
Smith Memorial Bridge
Berkshires in Autumn
Harlem Valley in Autumn
Centennial Commemorations
at Rensselaer, etc.

- The societies and organizations listed below cordially invite you and your friends to join with them in com-memorating one of the most important events in railroad history — THE COMPLETION AND FIRST THROUGH-OPERATION OF THE ORIGINAL HUDSON RIVER RAILROAD (now New York Central) from New York to East Albany (now Rensselaer) on October 1st, 1851.

- A de-luxe HUDSON RIVER RAILROAD CENTENNIAL TRAIN will operate up the majestic Hudson River Valley, at probably the nicest time of the year, on the date and schedule shown below, from Grand Central Terminal, New York City, to Rensselaer—important up-river center directly opposite the state capital of Albany. Thence, the Special will move on to Troy and pass over the Troy and Schenectady ("freight service only") Branch which follows the picturesque Mohawk River up to Schenectady.

- At the great industrial center, the Centennial Special will cross the main line of the New York Central and take the "freight service only" Carman-South Schenectady connection over to South Schenectady on the south side of the valley and pass over the "freight service" West Shore tracks to Unionville and into the great Selkirk Freight Yards. A photography stop will be made at Selkirk Engine Terminal to picture available locomotives.

- The Centennial Special will cross over the famous A. H. Smith Memorial Bridge at sunset and at slow speed. This New York Central high-level bridge affords superb views of the Hudson Valley in all directions from its high point of vantage. It is seldom available to passengers.

- The return trip will take the party to Chatham (over the Boston & Albany) and thence back to Grand Central Terminal over an entirely different pathway—the famous Harlem Valley-Berkshire Route. Arriving and after leaving Chatham there will be wonderful evening vistas of the Catskills and then the twilight ride down the old "Harlem Line" in its Berkshire autumnal glory, arriving conveniently at Grand Central Terminal.

- The stops of the Centennial Special from New York to Rensselaer will include most of the points of stop of the notable original Celebration Train which operated October 8th, 1851. Appropriate brief observances of the Hudson River Railroad Centennial are planned at all important stops of the Centennial Special including Rensselaer.

- Equipment—The Hudson River Railroad Centennial Special Autumn-Scenic Train will consist of modern deluxe New York Central air-conditioned, reclining-seat, broad-window coaches with Pacemaker observation-coach; dining car will serve breakfast, special table d'hote luncheon and special table d'hote dinner; sandwich and refreshment counter lounge car and baggage car set up for picture taking. Steam power will be used Harmon to Rensselaer; Diesel power from Rensselaer to Selkirk Engine Terminal and steam power Selkirk to White Plains, North Station. Electric power elsewhere. Famous Hudson Type, J3, engine will be our steam iron horse.

This flyer was issued by the New York Centralto publicize a history-themed fan trip. Besides commemorating the centennial of the Hudson River Railroad with the dedication of a monument in the Rensselaer yard, the trip took in several branches and divisions as well as the great Selkirk rail yards. A similar trip today would generate incredible fervor among railfans. (Author's collection.)

Centennial of the Completion

of the

Hudson River Railroad

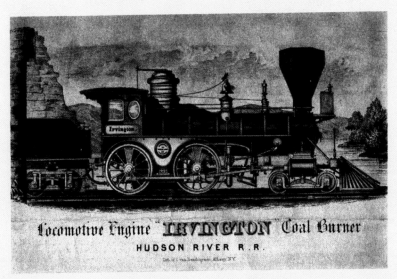

Locomotive Engine "IRVINGTON" Coal Burner

HUDSON RIVER R. R.

New York City to East Albany

now Rensselaer

October 1st, 1851

Observed at Rensselaer — Saturday, September 29th, 1951 by

Railway and Locomotive Historical Society, Inc.
National Railway Historical Society
Hudson River Conservation Society

Railroad Enthusiasts, Inc.
Railroadians of America
New York Historical Society

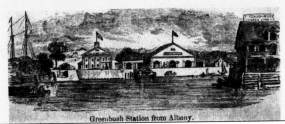

Greenbush Station from Albany.

The highlight of the fan trip of September 29, 1951, was a dedication ceremony at Rensselaer to commemorate a century of Hudson Valley rail service. Six different historical societies were involved in the celebration. A stone cairn with an impressive bronze plaque was unveiled. Its whereabouts are unknown today. It disappeared sometime during the reconstruction of the yard in the late 1960s. (Author's collection.)

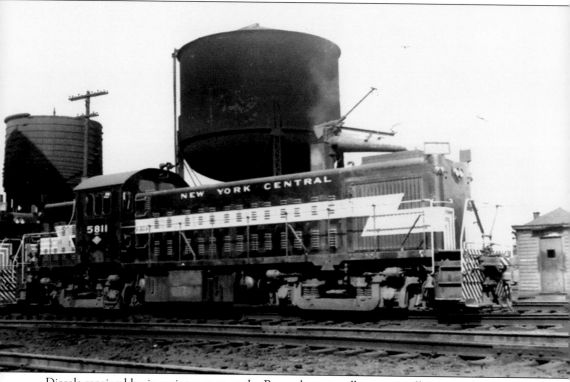

Diesels received basic maintenance at the Rensselaer roundhouse as well as steam locomotives. In this September 1951 scene, Lima-Hamilton 1,200-horsepower unit 5811 has been serviced and will soon be given its next assignment, probably a passenger train. (Photograph by Edward L. May.)

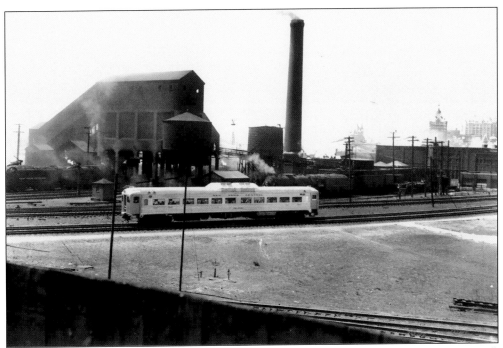

One of the New York Central's brand-new Budd RDC-1's (called Beeliners on the Central) rolls past the Rensselaer engine house complex as it begins its morning eastbound run over the Boston and Albany. (Courtesy of Len Kilian.)

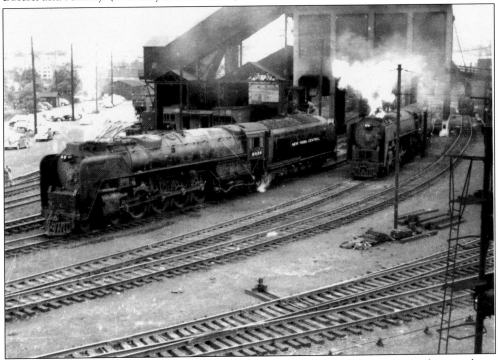

On this early-1950s day, a pair of the New York Central's massive Niagara types has just been serviced at the engine house and is ready for the road. (Courtesy of Dick Barrett.)

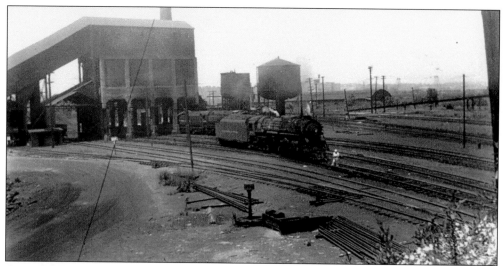

One of the workhorse Hudsons has just been coaled and watered at the engine house and is being sent out to its assignment in this 1950 scene. (Photograph by Charles L. Ballard.)

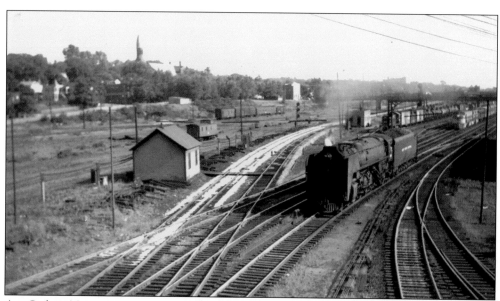

An S-class Niagara waits for a westbound passenger train, pulled by E-units (visible in right distance) to clear Tower 99's plant. This view is from the early 1950s. (Photograph by Charles L. Ballard.)

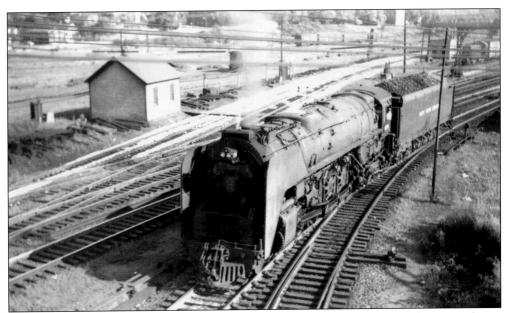

In this 1954 scene, a Niagara awaits permission from Tower 99 to head into the engine house complex for routine servicing. (Photograph by Charles L. Ballard.)

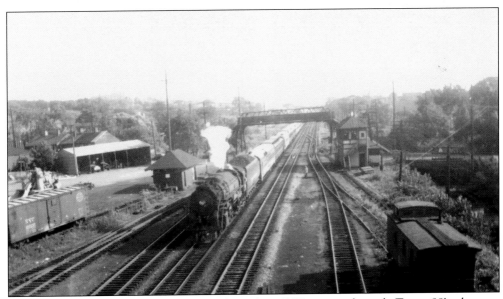

Train 49, the *Advance Knickerbocker* with Hudson 5422 passes through Tower 98's plant on July 30, 1953. Albany's Union Station is minutes away. (Photograph by Charles L. Ballard.)

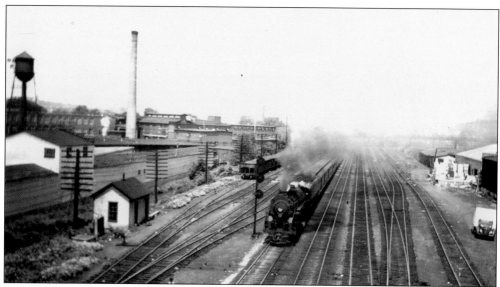

Train 146, an Albany-to-New York local passes the Huyck Mills complex on July 22, 1953. The power on this day was a J-class Hudson. (Photograph by Charles L. Ballard.)

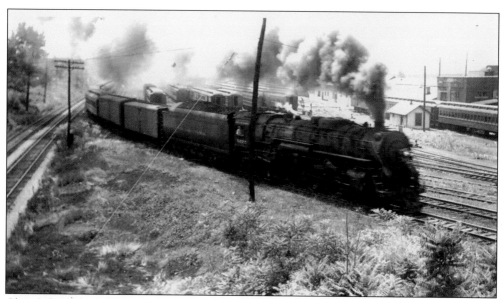

Class J-1b Hudson 5333 swings onto the Livingston Avenue Bridge with a westbound express train. The Troy Branch, still double tracked at the time, is seen at left. The view is from July 1955. (Photograph by Charles L. Ballard.)

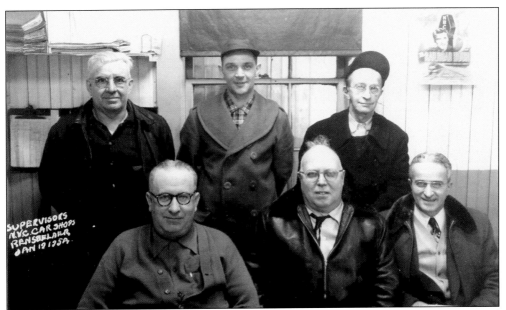

The New York Central car shop at Rensselaer was at the north end of the yard in the area called the "Sand Lot." This area is today covered by the Amtrak complex. The supervisory crew of the shop posed for a group photograph in 1954. (Author's collection.)

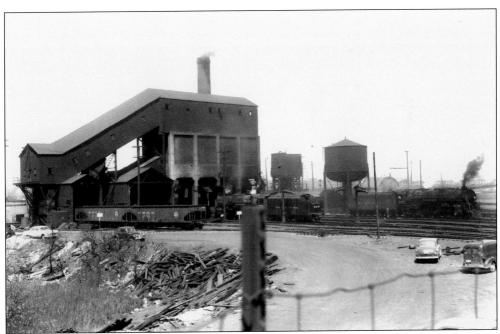

The venerable old coaling station is host to two New York Central Hudsons in this 1954 scene. The dirt road in the foreground later became the entrance to the new Rensselaer High School. Today the school is but a memory, and the area is being commercially developed. (Courtesy of Len Kilian.)

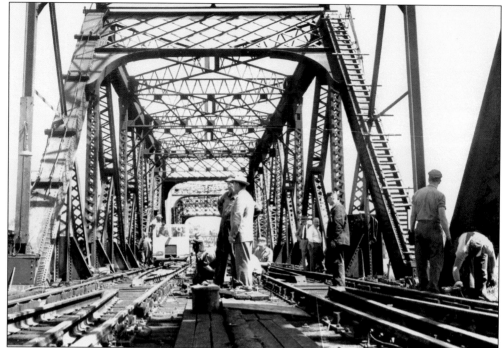

Signal and track department crews work to repair damage to the Maiden Lane Bridge from a fire of unknown origin. This was the passenger bridge that connected Albany to Rensselaer's gateway to Troy, Boston, and New York. The Livingston Avenue Bridge (the freight bridge) also spanned the Hudson just to the north. The repairs on the bridge's swing span was nearly complete in this May 20, 1955, scene. (Author's collection.)

The smiling gentleman on the left is Vince "Dodger" Farrell, a brakeman for the New York Central who enjoyed a long career. Besides his love for the railroad, Dodger, a Rensselaer native, was noted for his amusing stories and the fact that he was a highly skilled woodcarver. (Courtesy of Margaret Farrell.)

60

Three

DECLINE AND DISUSE

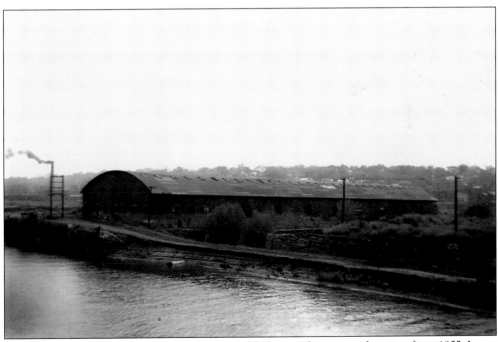

The flourhouse, a very large freight house, stood forlorn and empty in this view from 1955. It was built in 1845 and was for a time the western terminus of the Boston and Albany. When new, it was touted as one of the largest buildings in the United States. It survived until the construction of Rensselaer High School in 1969. (Author's collection.)

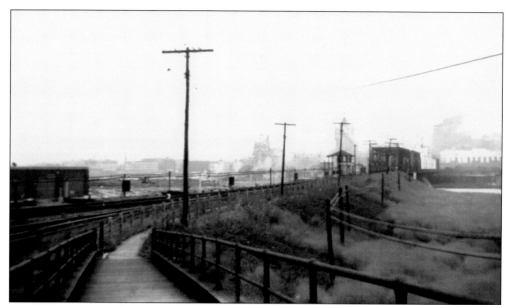

This 1955 view is from the pedestrian walkway to the Maiden Lane Bridge. Signal Station 101 can be seen at the east end of the bridge. The roundhouse had just recently been demolished. It had stood in the empty area past the tracks in the center of the picture. (Author's collection.)

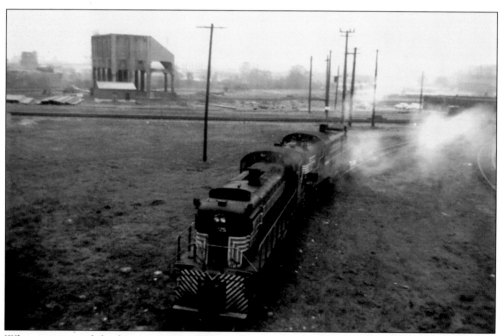

What remains of the locomotive coaling facility stands ghostlike in this 1955 view while two RS-3s negotiate the north leg of the wye. The recently dismantled roundhouse stood in the area directly above the diesels. (Author's collection.)

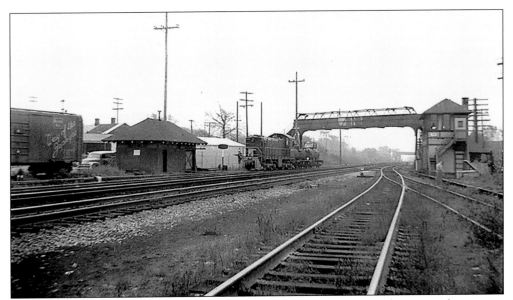

Tower 98 stood at Second Avenue in Rensselaer, where there had once been a grade crossing. When the crossing was eliminated, the pedestrian bridge was erected. On this day in 1955, an Alco yard switcher moves tank cars through Tower 98's plant. (Author's collection.)

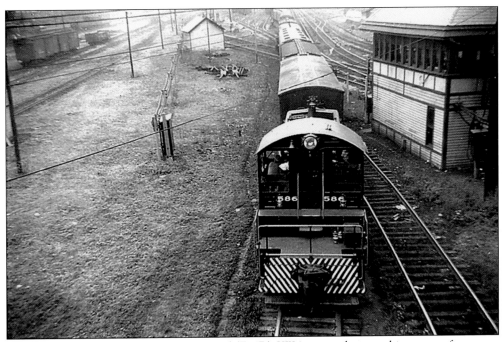

Yard switcher 586, an Electro-Motive Diesel (EMD) SW-1, is seen here working a cut of cars past Tower 99. The 586 was built in 1949 and later renumbered 8412. It was used for many years as a passenger switcher in Albany Union Station and later, Albany-Rensselaer. This scene is from 1955. (Author's collection.)

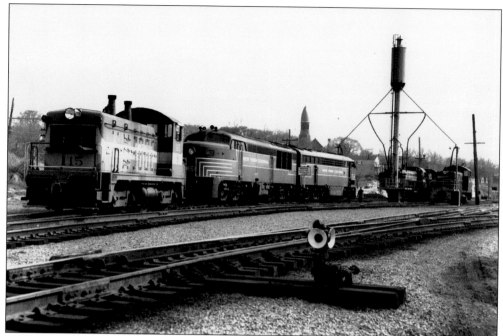

April 14, 1957, saw an interesting group of locomotives assembled at the fueling plant. EMD NW-2 115 was an acquisition from the recently shut down New York, Ontario and Western Railway. Behind the 115 is a pair of Fairbanks-Morse units; an "Erie built" and a "C-Liner." (Photograph by Jim Shaughnessy.)

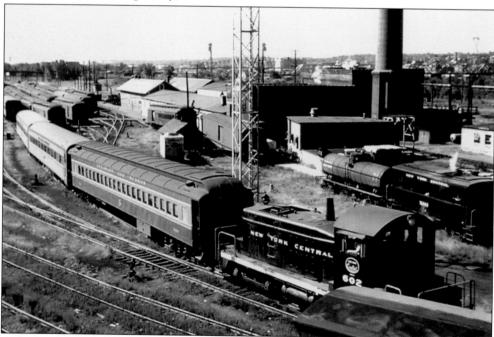

As late as this 1957 day, the coach yard and car shop at the north end of the yard still enjoyed a reasonably healthy business. EMD SW-1 602 sports the newer-style New York Central emblem as it pulls a cut of coaches. (Photograph by Gerrit Bruins; courtesy of Len Kilian.)

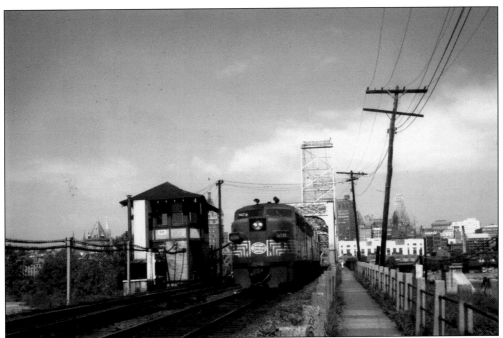

Alco PA-1 4208 rolls past Signal Station 101 at the east end of the Maiden Lane Bridge with a light-engine move. Virtually everything in this 1958 scene is gone today. (Photograph by Gerrit Bruins; courtesy of Len Kilian.)

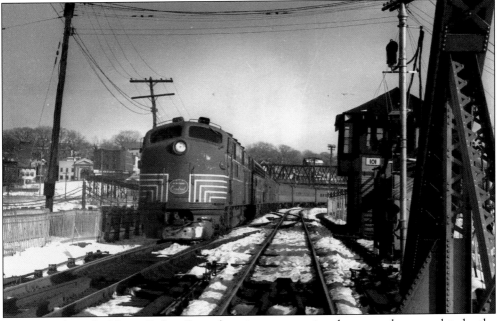

This westbound New York Central passenger train has nearly completed the New York-to-Albany leg of its run. The EMD E-7 in the lead wears the short-lived "modern" version of the New York Central's oval logo. Seen here, the train is passing Tower 101, which guarded the east end of the Maiden Lane Bridge. The last evidence of winter is seen in this March 1959 scene. (Photograph by Jim Shaughnessy.)

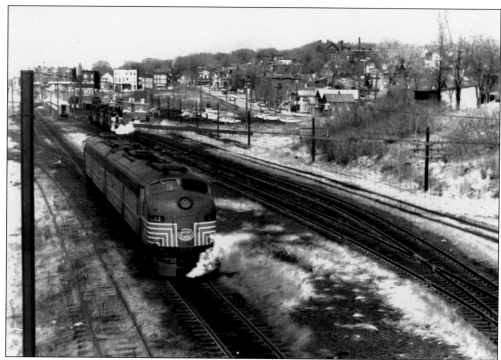

This March 1959 scene was shot from the long-gone Herrick Street Bridge. Two of New York Central's fast E-8 passenger locomotives have just been serviced at the Rensselaer fueling plant and are awaiting assignment. East Street is seen in the background. (Photograph by Jim Shaughnessy.)

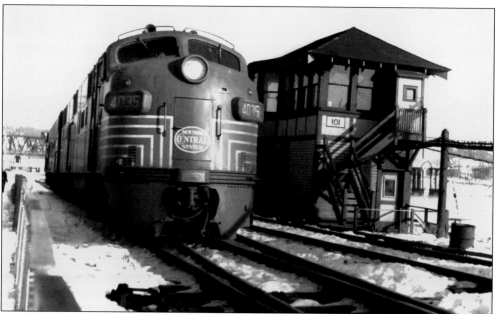

An Albany-bound passenger train passes Tower 101 at the Rensselaer end of the Maiden Lane Bridge. The 4035's run from New York is almost over in this March 1959 scene. (Photograph by Jim Shaughnessy.)

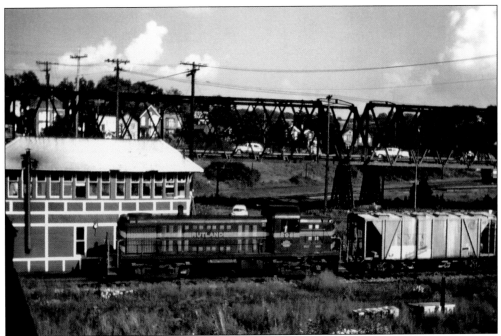

On this sunny July day in 1959, Rutland Railroad freight CR-1 powered by RS-3 208 passes Signal Station 100. After Rutland's track from Bennington to Chatham was torn up in 1953, this train ran from Chatham to Troy over the New York Central and Boston and Albany's and over the Boston and Maine from Troy to its own home rails. (Photograph by Gerrit Bruins; courtesy of Len Kilian.)

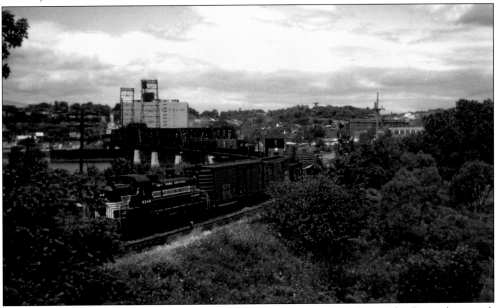

A New York Central local freight swings off the freight bridge with cars for Rensselaer yard. Lightning-striped Alco RS-3 8344 is the power. Signal Station (tower) D was located at the east end of the bridge. This bridge is still used by CSX and Amtrak and rests on piers from the original bridge of 1866. (Photograph by Gerrit Bruins; courtesy of Len Kilian.)

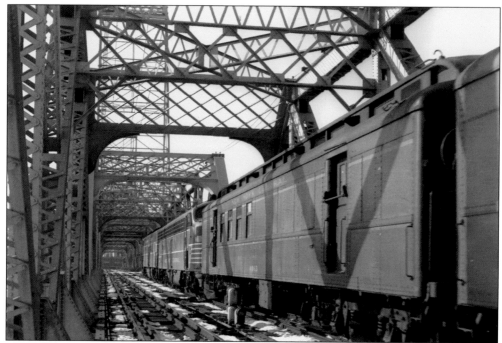

The Maiden Lane Bridge (the passenger bridge) was built by the Hudson River Bridge Company, a subsidiary of the New York Central and Hudson River Railroad in 1900. In March 1959, a westbound passenger train is crossing the bridge from Rensselaer to Albany's Union Station. When the station was moved to Rensselaer in 1968, the bridge was no longer needed, and shortly after, was dismantled. (Photograph by Jim Shaughnessy.)

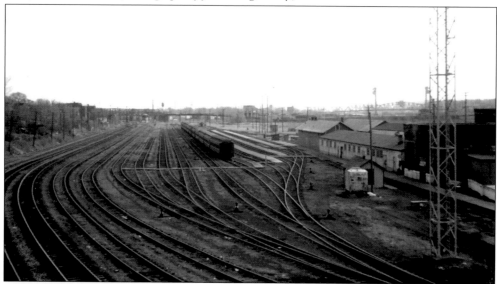

The nationwide decline in passenger business is dramatically illustrated in this 1960 view of the coach yard in Rensselaer. The yard tracks in this scene would soon be ripped up. The two more polished tracks at the left are curving onto the Livingston Avenue Bridge, used mainly at the time for freight. This area would years later be the site of an Amtrak maintenance facility. (Photograph by Gerrit Bruins; courtesy of Len Kilian.)

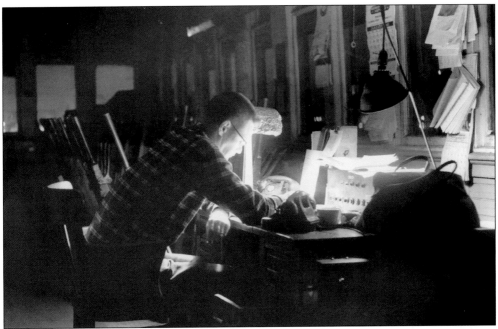

Towerman Branson Van Dyk fills out his train sheet on the graveyard shift at Signal Station 99 on the west side of Rensselaer yard. This lonely scene was recorded on January 17, 1961. Within a decade, this tower, along with the other four in Rensselaer yard, would be history. (Photograph by Jim Shaughnessy.)

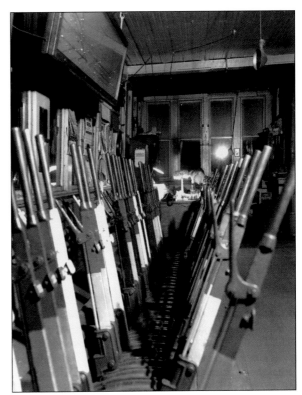

Well into the 1960s, the five interlocking towers in Rensselaer yard were "open day and night" as the employee timetable announced. Towerman Branson Van Dyk is seen at work at the end of Tower 99's lever machine. (Photograph by Jim Shaughnessy.)

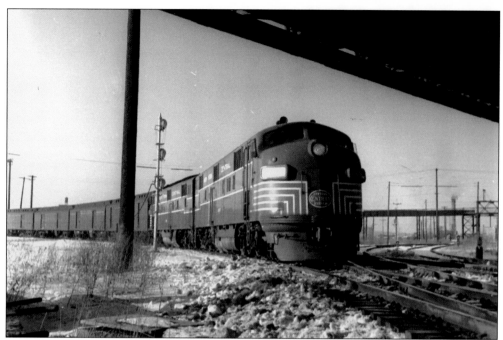

In January 1961, two New York Central E-7s lead a late afternoon train off the Maiden Lane Bridge and onto the Hudson Division to New York. This train is showing a heavy "head end" business of mail and express cars. The train is passing the former roundhouse site and is about to duck under the Broadway Viaduct. (Photograph by Jim Shaughnessy.)

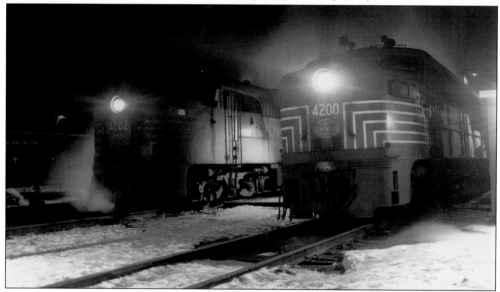

The New York Central demolished its Rensselaer roundhouse in 1955 when dieselization of its eastern lines was complete. Shortly afterwards, the company built a diesel locomotive fueling plant and light maintenance facility over on the East Street side of the yard. In this January 1961 scene, two Schenectady-built PA-1 locomotives await servicing. These passenger units were not as common on the New York Central as their EMD E-unit sisters. (Photograph by Jim Shaughnessy.)

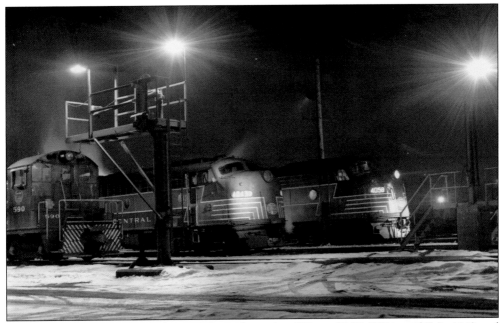

On a bitterly cold January night in 1961, yard switcher 590, an EMD SW-1, and E-8s 4043 and 4058 have been serviced at the Rensselaer fueling plant and await their assignments. (Photograph by Jim Shaughnessy.)

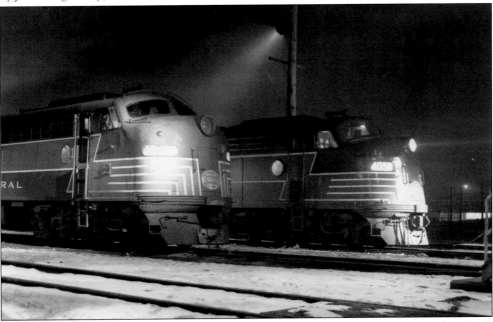

In the diesel era, most of the New York Central's crack passenger trains were hauled by EMD E-7s and E-8s. They were fast and dependable. The trains of the "Great Steel Fleet" (the *20th Century Limited, Empire State Express, Pacemaker, Wolverine, Detroiter, New England States Limited*, and so forth), usually had one of these racehorses on the point. Here the 4043 and the 4058 have just been serviced at the Rensselaer fueling plant in January 1961. (Photograph by Jim Shaughnessy.)

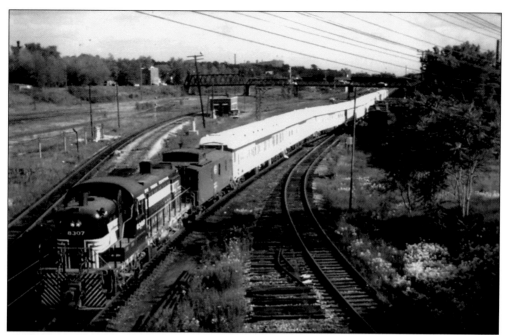

On a sunny afternoon in 1962, the "Grade Job," a local freight, switches the circus train of the James E. Strates Shows. By this date, the Boston and Albany main has been reduced to one track (over the engine) and signs of declining business are everywhere. More than most, this photograph shows Rensselaer yard at its lowest point. Within a decade and a half, Rensselaer would come charging back as a vital rail center. (Photograph by Gerrit Bruins; courtesy of Len Kilian.)

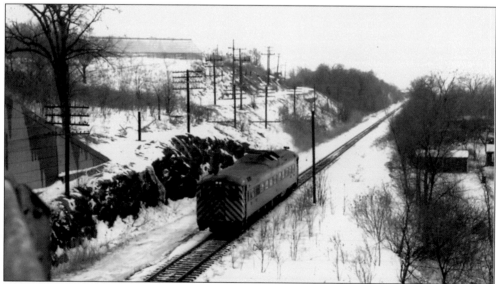

In this February 1963 scene, Boston and Albany train 405, a Beeliner, is about to pass under Columbia Street on its way into Albany's Union Station. The light snow on the ground enables the viewer to see the roadbed of the Albany Southern, an electric interurban road, which went to Hudson, New York, and last ran in December 1929. The roadbed can be seen halfway up the hill, directly over the Budd car. (Photograph by Gerrit Bruins; courtesy of Len Kilian.)

The Albany depot switcher with S-1 8412 pulls a coach and an RS-3 past the ruins of the coaling tower in this 1966 scene. The centennial monument to the Hudson River Railroad, placed in 1951, can be seen near the passenger car. (Photograph by Gerrit Bruins; courtesy of Len Kilian.)

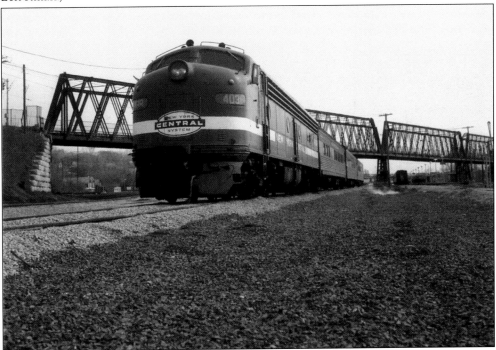

In this scene from April 1968, a New York Central mail train accelerates through Rensselaer yard with EMD E-8 4038 on the point. The Pennsylvania Railroad and New York Central merger is imminent, and within a few months of this date, the Albany Station would be located here. (Photograph by Steve Brown.)

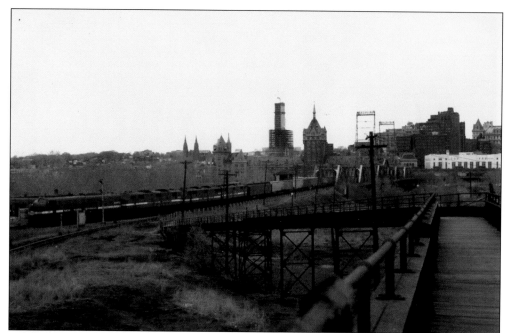

An E-8 and three E-7s roll a Boston-bound morning mail train off the Maiden Lane Bridge. This April 1968 photograph was taken from the pedestrian walkway to Albany. The Corning Tower of Gov. Nelson Rockefeller's Empire State Plaza (then called the South Mall) rises under construction in the background. Within a year, the Albany Station will be on this side of the river. (Photograph by Gerrit Bruins; courtesy of Len Kilian.)

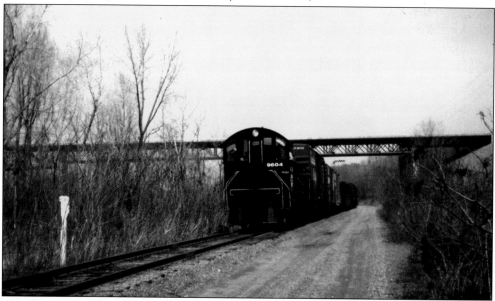

The "Troy Job" of the newly created Penn Central drifts into Rensselaer with Alco S-2 9604 in this November 1968 view. In the succeeding few years, the Troy Branch came very close to being ripped up. This line is used almost daily today by CSX or Canadian Pacific. It is the only rail line to Troy, which was once a major rail center. The unfinished Patroon Island Bridge is seen in the background. (Photograph by Ernie Mann.)

74

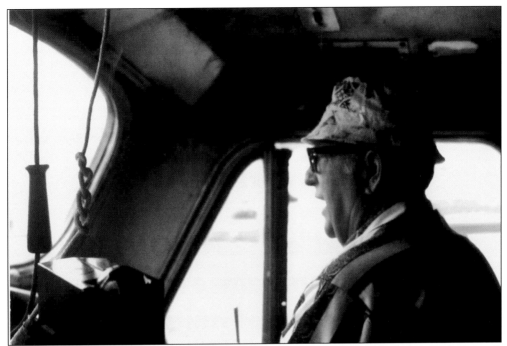

Rensselaer native William "Lump" Leffler was a gregarious and well-liked New York Central, Penn Central, and Conrail engineer. He is shown here at the throttle of a Penn Central E-8 locomotive. (Photograph by Ernie Mann.)

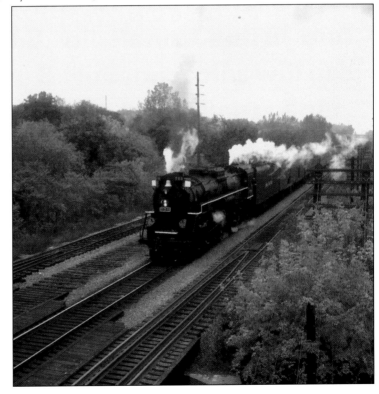

Ex–Nickel Plate 2-8-4 Berkshire 759 made several shakedown and fan trips before its celebrated run on the *Golden Spike Special* in 1969. Here it is seen on a westbound run entering Rensselaer in October 1968. (Photograph by Steve Brown.)

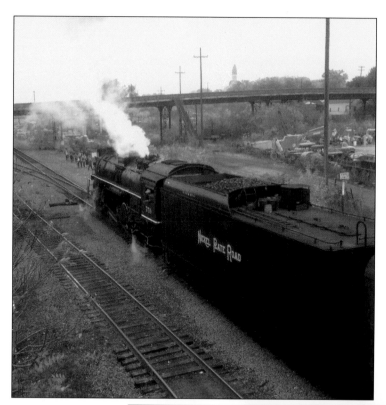

On October 12, 1968, ex–Nickel Plate Berkshire-type 759 approaches the Third Avenue Bridge as it enters Rensselaer yard with an excursion train. (Photograph by Steve Brown.)

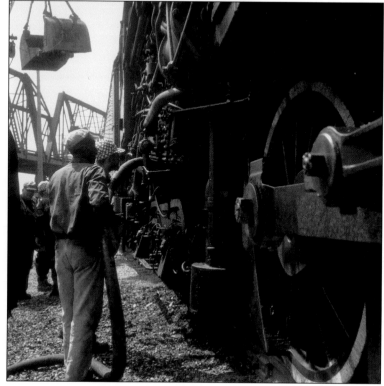

October 12, 1968, saw a spectacular excursion train pass through town. The celebrated engine 759 is seen here getting replenished with coal and water at Rensselaer before continuing its westward journey. The following year, the same engine would pull the *Golden Spike Special* to celebrate a century of the transcontinental railroad. (Photograph by Steve Brown.)

NOTICE

ALBANY, N.Y. CHANGE OF STATION LOCATION

WE'RE MOVING! To better serve you, we are moving to a *New Modern* station to serve ALBANY–RENSSELAER, N.Y. area. Effective 11.00 P. M., Sunday, *December 29th*, 1968, all Penn Central and Delaware & Hudson trains will use our new facilities at Rensselaer, N.Y.

PENN CENTRAL

Penn Central's official spin was that a "New Modern" Albany station across the Hudson River in Rensselaer was a positive step. In actuality, it signaled another downturn in American rail passenger service. The large, classic Albany Union Station, which opened in 1900, was simply no longer needed due to declining service and ridership. Its tracks were in the way of the planned riverfront arterial highway. The postwar optimism regarding passenger service was all but gone by 1968. A decade later, things would change for the better. (Author's collection.)

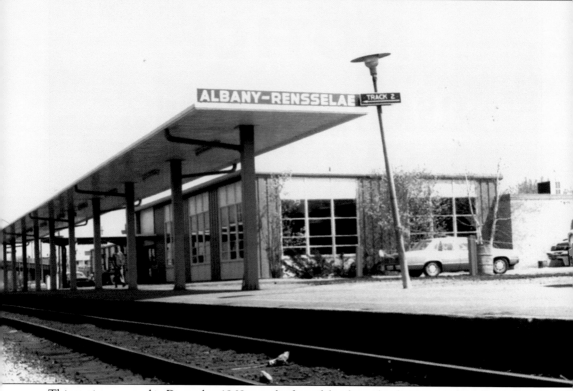

This station, opened in December 1968, was the first of the three that have carried the designation Albany-Rensselaer. It was built by Penn Central so that the large classic Albany Union Station could be closed. Despite the touting of it being new and modern, this structure actually symbolized the dramatic downturn in the demand for passenger train service. (Photograph by Ernie Mann.)

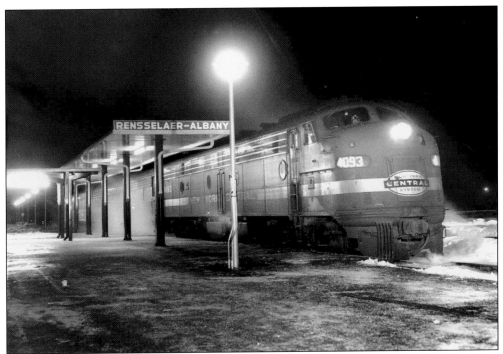

This is the first Penn "Empire Service" train to arrive at the new station from New York. The date is December 29, 1968. Rensselaerites were proud of the new facility and even prouder that the first station signs had Rensselaer's name first. They were soon changed. (Photograph by Jim Shaughnessy.)

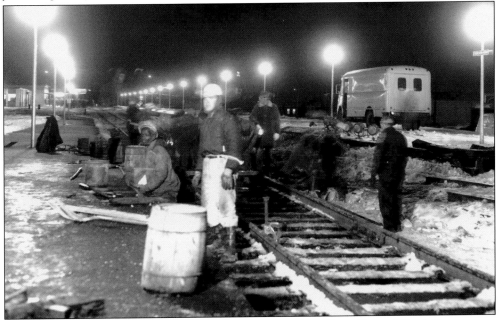

It was late at night on December 29, 1968, and bitterly cold as Penn Central Track Department employees worked overtime to finish connections to the newly opened Albany-Rensselaer station. (Photograph by Jim Shaughnessy.)

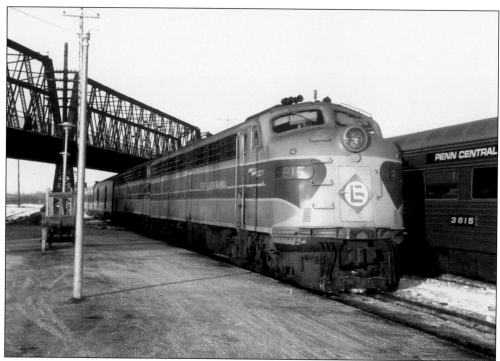

On a sunny April 1971 day, the Delaware and Hudson's southbound *Laurentian* is seen arriving at Albany-Rensselaer. Two classic Erie-Lackawanna E-8s have just brought the train down the Champlain Valley from Montreal. (Photograph by Steve Brown.)

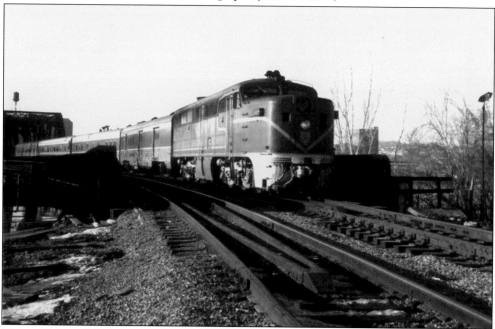

The southbound Delaware and Hudson *Laurentian* swings off the Livingston Avenue Bridge minutes away from its arrival in Albany-Rensselaer at Penn Central's still-new station. This scene dates to March 1969. (Photograph by Steve Brown.)

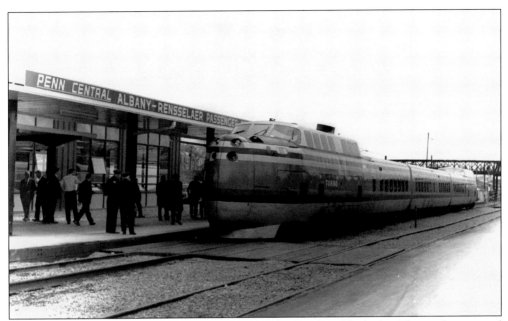

The first American turbo trains were built by United Aircraft and looked it. This set has stopped at the new station while on an extended demonstration tour. Only a few sets of these trains were built. They were fast but were plagued by occasional electrical fires. This view is from April 21, 1969. (Photograph by Jim Shaughnessy.)

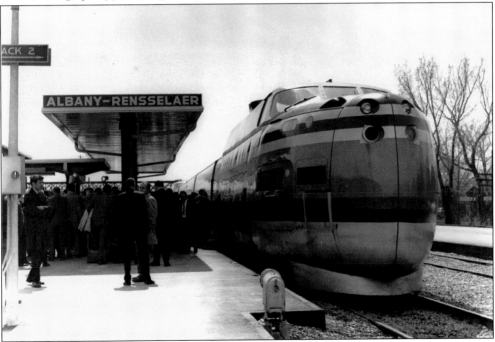

One of the first generations of turbo trains is seen here, being showcased by Penn Central at its new station in Rensselaer. A large crowd has assembled to admire the radical styling of these United Aircraft units. The large nose doors could be opened for servicing. This scene is from April 1969. (Photograph by Jim Shaughnessy.)

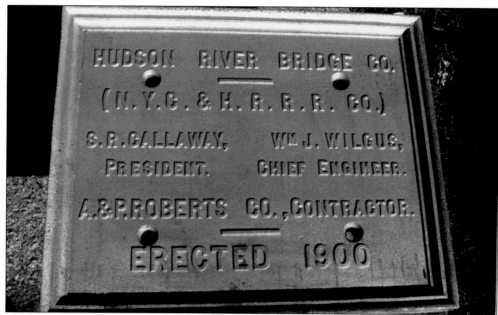

When the Maiden Lane Bridge was dismantled in 1969, the large builder's plate was thankfully saved. The Hudson River Bridge Company was a subsidiary of the New York Central and Hudson River Railroad. Samuel R. Callaway was the railroad's president. William Wilgus is more famous for being the designer of Grand Central Terminal in New York. (Author's collection.)

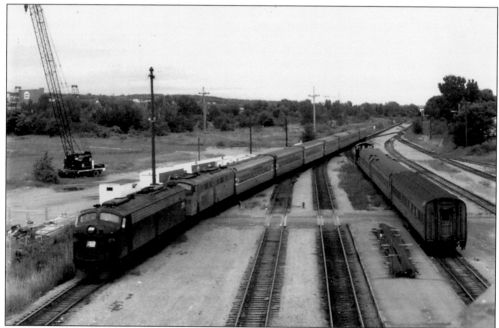

In June 1971, an eastbound Amtrak train powered by two E-units enters the recently reconfigured railroad yard as it arrives at the Albany-Rensselaer station. The construction site of the new Rensselaer High School campus is at left. (Photograph by Gerrit Bruins; courtesy of Len Kilian.)

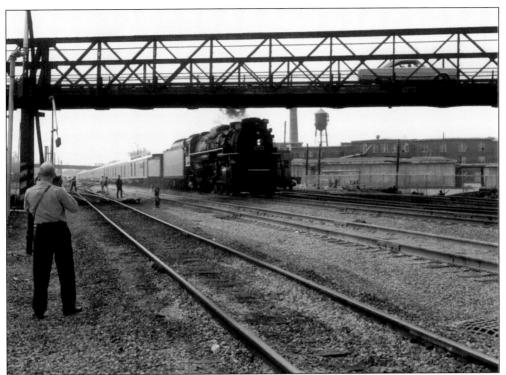

In 1969, the *Golden Spike Special* toured the country to commemorate the completion of the transcontinental railroad a century earlier. In this scene from May of that year, ex–Nickel Plate 2-8-4 Berkshire 759 pulls the special into Rensselaer yard. (Photograph by Steve Brown.)

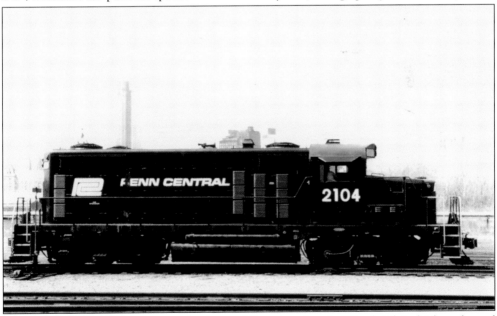

Penn Central GP-20 2104 is seen in the depot while assigned to the "Grade Job," which performed switching duties at Castleton, the port of Rensselaer, and West Albany. This view is from April 1975. (Author's collection.)

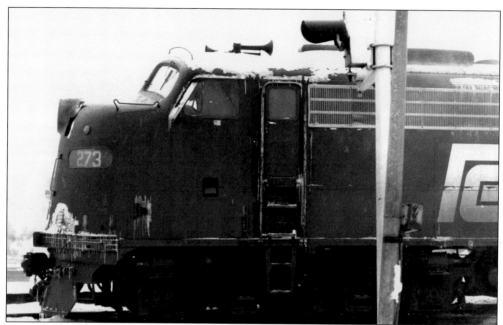

It is minus five degrees as Amtrak E-8 273 (ex–Penn Central 273, ex–New York Central 4058) prepares for departure on the head end of train 448, the Boston section of the *Lake Shore Limited*. In a matter of minutes, the 273 and two E-unit sisters will begin a near-continuous 58 miles uphill into the Berkshires. The train will also encounter a substantial coating of mountain snow. The 273 still sports her Penn-Central paint on this January 10, 1977, date. (Photograph by Ernie Mann.)

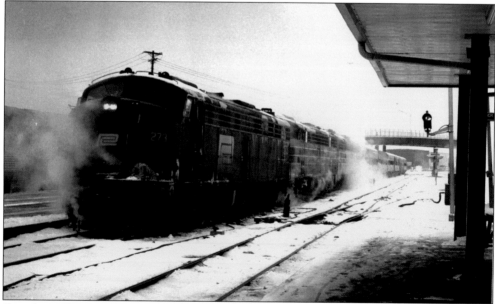

On subzero January 10, 1977, Amtrak train 448, the Boston section of the *Lake Shore Limited*, prepares for its uphill run over the Berkshires. The train is already two and a half hours late and given the weather, making up time is unlikely. On this day however, 448's passengers are probably better off than their counterparts in cars, buses, and planes. (Photograph by Ernie Mann.)

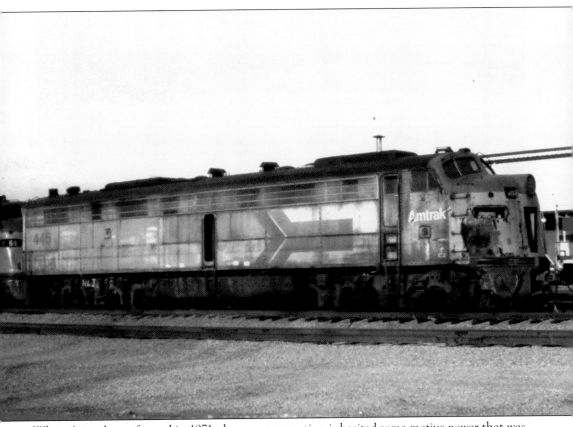

When Amtrak was formed in 1971, the new corporation inherited some motive power that was more suited for a junkyard than on the point of a passenger train. An example is ex–Seaboard Coast Line E-8 445, shown at the Rensselaer shop in 1976. (Photograph by Ernie Mann.)

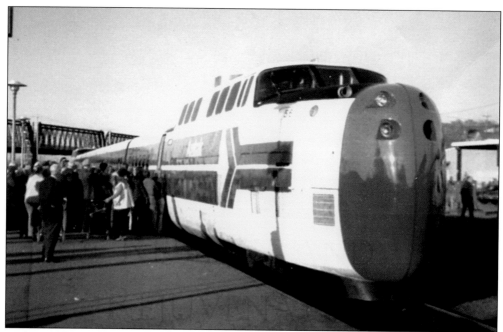

In the early 1970s, Amtrak sent the United Aircraft Turbotrain on a nationwide publicity tour. Here the train draws a crowd at the Rensselaer station. The train set sports a different paint scheme than that of the previous publicity trip. (Photograph by Ernie Mann.)

The New York Central, Penn Central, and Conrail all made extensive use of transfer cabooses in local freight yards. Conductors and brakemen appreciated the visibility that the roomy platforms afforded while performing switching duties. This way car is seen passing through the depot on a spring day in 1980. (Photograph by Gerrit Bruins; courtesy of Len Kilian.)

Four

REBIRTH AND REJUVENATION

All three Albany-Rensselaer stations can be seen in this view. The structure on the left was the original 1968 Penn Central Station. The middle building with the dark overhanging roof was opened by Amtrak in 1981. The current station is at the right. This impressive depot with clock tower was built by the Capital District Transit Authority and opened in 2002. (Photograph by Ernie Mann.)

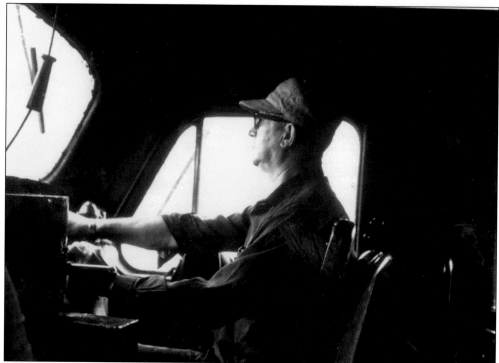

Penn Central engineer Ulster D. Brown was a Rensselaer native who went to work on the New York Central's Mohawk Division in 1942. He is seen at the throttle of an E-unit, running a mail train in 1969. (Photograph by Steve Brown.)

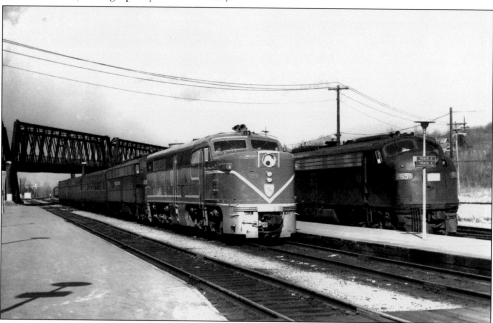

Delaware and Hudson PA-4 19 arrives at Rensselaer on the point of Amtrak train 74 from Buffalo. The 19 has just been rebuilt by Morrison-Knudsen at Boise. Ex–New York Central E-8 255 is at right in this February 26, 1975, scene. (Photograph by Jim Shaughnessy.)

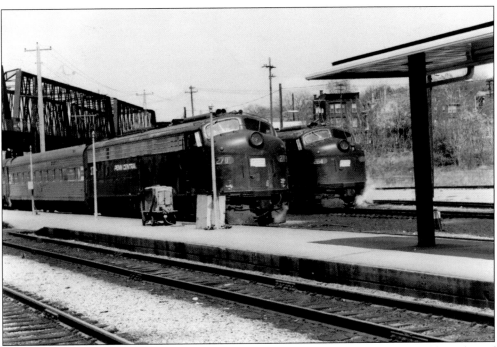

For a few years, locomotives could be seen throughout the Amtrak system wearing the colors of their predecessor owners. Here in 1977, former Penn Central E-8s 270 and 264 are at Rensselaer awaiting their eventual runs to New York. Both engines were originally from the New York Central. (Photograph by Steve Lackmann.)

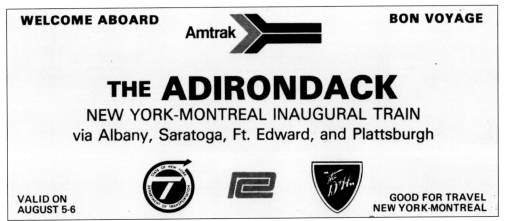

This souvenir ticket was issued to passengers and invited dignitaries aboard the inaugural run of the *Adirondack* on August 5, 1974. Although technically an Amtrak train, it used unique and beautiful Delaware and Hudson equipment. By this date, the "Albany" on the ticket was in reality Rensselaer. (Author's collection.)

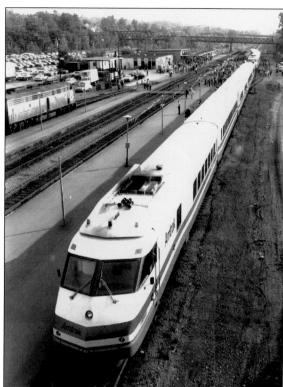

One of the sleek new Rohr Turboliner sets is on display during the dedication of this service on September 19, 1976. These units were built at Chula Vista, California. They ran over the Empire Corridor, New York, to Niagara Falls, and were the chief reason the large locomotives shop was built at Rensselaer. (Photograph by Jim Shaughnessy.)

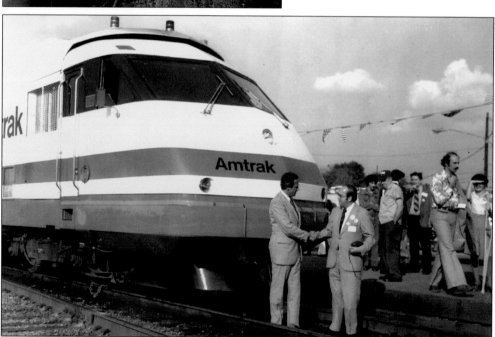

New York State transportation commissioner Raymond T. Schuler greets Dave Bulman, a New York State Department of Transportation employee who was also a member of the Mohawk and Hudson Chapter of the National Railway Historical Society. The occasion was the dedication of Rohr Turboliner service on September 19, 1976. (Photograph by Jim Shaughnessy.)

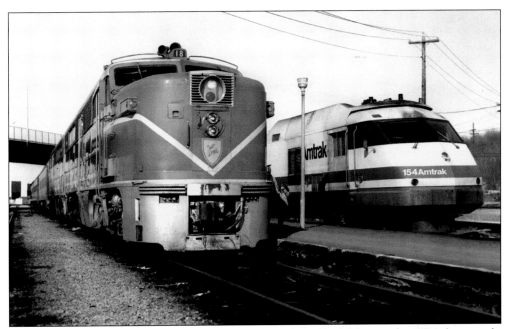

The "Pride of Schenectady" is flanked by the interloper from Chula Vista in this 1976 photograph. The classic lines of Alco's PAs earned them the nickname "honorary steam locomotives" from railfans. The brand new Rohr Turboliners would become popular with passengers and would race across New York State for nearly three decades. (Photograph by Jim Shaughnessy.)

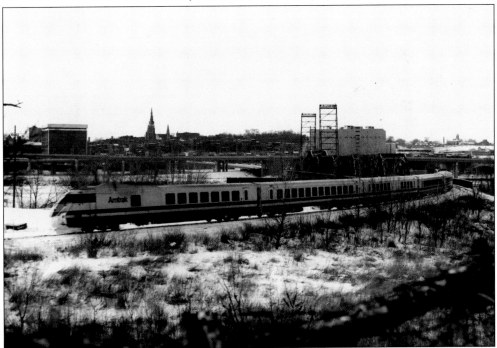

An eastbound Amtrak Empire Service train, consisting of one of the new Rohr Turboliner sets, swings off the Livingston Avenue Bridge as it arrives at Rensselaer. This scene is from 1976. (Photograph by Jim Shaughnessy.)

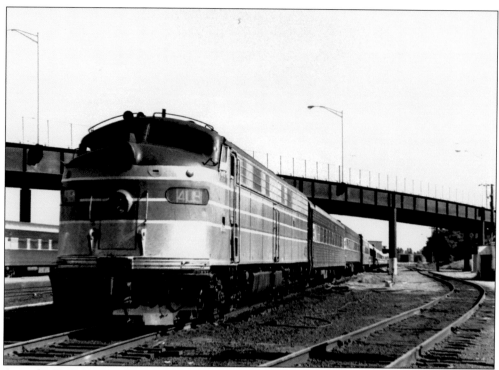

Amtrak's EMD E-9 409 brings an eastbound passenger train into Rensselaer Station. The "new" Broadway Viaduct, which opened in 1975, is in the background. (Photograph by Ernie Mann.)

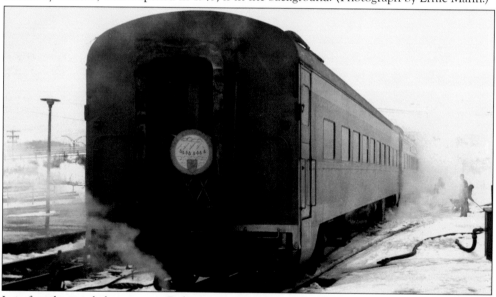

It is five degrees below zero as Delaware and Hudson (Amtrak) train 69, the *Adirondack*, is only minutes from departure from Rensselaer. On its run to Windsor Station in Montreal, the train faces several hours of brutal cold and drifting snow in the Champlain Valley. Although an Amtrak train, the Delaware and Hudson was still at this time supplying its own cars and locomotives. A rare touch of class in those days was the tail-end "drumhead" sign. This scene was on January 10, 1977. (Photograph by Ernie Mann.)

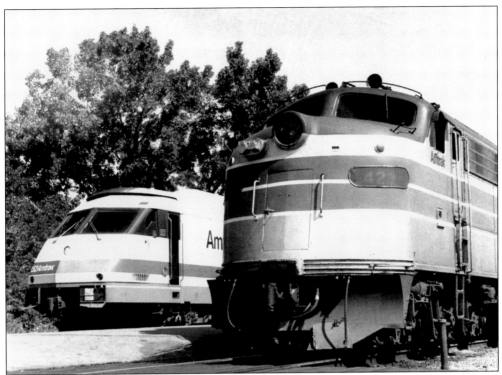

Two generations of passenger locomotive power are seen side-by-side at Rensselaer in 1977. The new Rohr Turboliners will soon take over the bulk of Amtrak runs on the Empire Corridor while the classic EMD E-9 (ex–Union Pacific) will be phased out. (Photograph by Ernie Mann.)

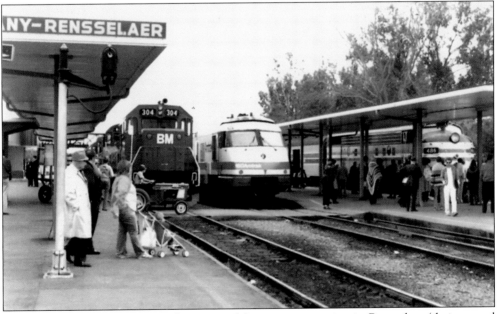

In 1981, Amtrak staged an open house to celebrate its new station in Rensselaer (their second one). On display were locomotives from Amtrak, Conrail, Delaware and Hudson, and Boston and Maine. (Photograph by Ernie Mann.)

This sign greets visitors when they arrive at the sprawling Rensselaer locomotive complex. (Photograph by Ernie Mann.)

An Amtrak Rohr Turboliner set swings out of Rensselaer yard at the start of another race across New York State in this March 1978 scene. (Photograph by Ernie Mann.)

94

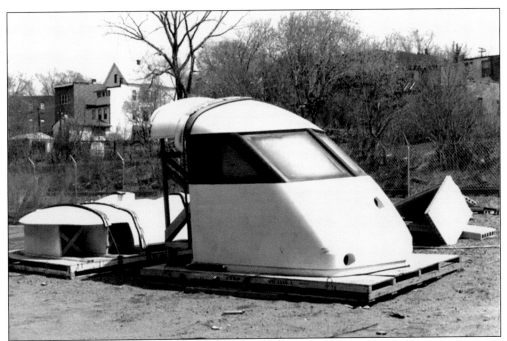

The principal function of the Rensselaer Maintenance Facility was to service the new Rohr Turboliners, which made their debut in 1976. One of the efficiency features of these units was the relative ease of repair of some kinds of accident damage. Here are seen extra fiberglass noses and roof cowls stored for future needs. (Photograph by Ernie Mann.)

This Amtrak turbo power car was heavily damaged in an accident. It has just received a new fiberglass nose at the Rensselaer shop on this 1978 day. (Photograph by Ernie Mann.)

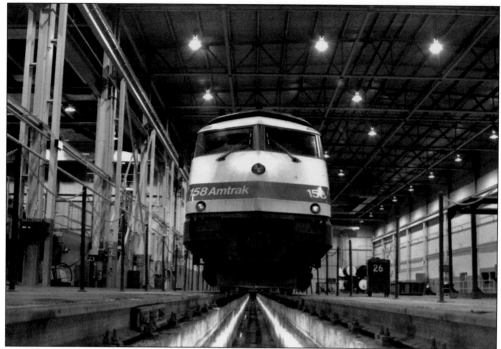

The Rensselaer Turbo Maintenance Facility was still new in this scene, with Rohr Turboliner 158 in for routine work. The Turbotrains were the primary reason that Amtrak built the large complex. (Photograph by Jim Shaughnessy.)

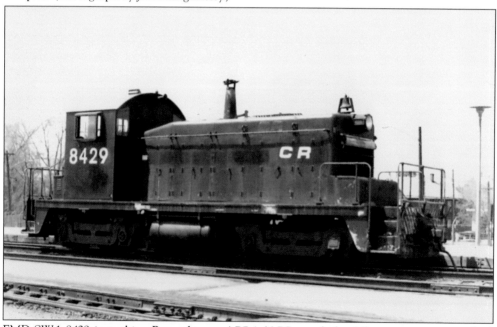

EMD SW-1 8429 is working Rensselaer as APS-1 (APS stands for Albany passenger switcher) on this April 1980 day. This engine and sister unit 8412 powered this assignment for many years for New York Central, Penn Central, and Conrail in Albany stations on both sides of the river. (Photograph by Ernie Mann.)

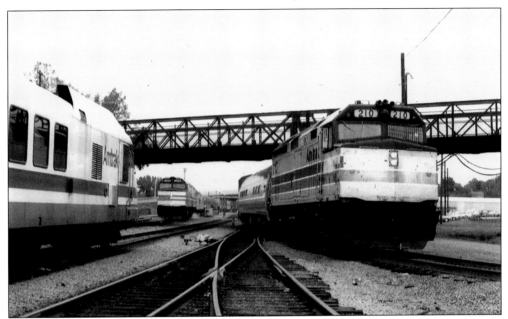

Rensselaer's station was a busy place on August 28, 1980, as three passenger trains occupied the depot's tracks. At left, train 77, with a Rohr Turboset, arrives from New York. In the center, train 48, the *Lake Shore Limited*, prepares for departure to the big city. The Boston section of the *Lake Shore Limited* with F-40 210 on the point is at right. The *Lake Shore Limited* came to Rensselaer from Chicago, then were split for their respective cities. (Photograph by Ernie Mann.)

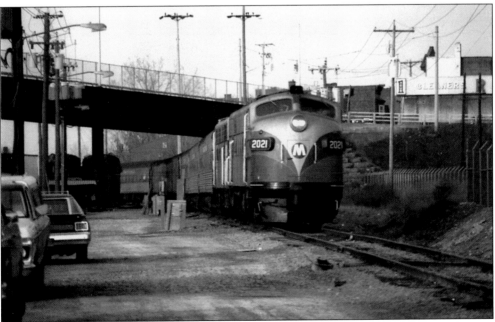

In the 1980s, it was common on the Sunday after Thanksgiving to see strange equipment borrowed by Amtrak for extra trains. On November 24, 1984, two Metro-North FL-9s and a string of commuter coaches are being readied for an extra run to New York. (Photograph by Ernie Mann.)

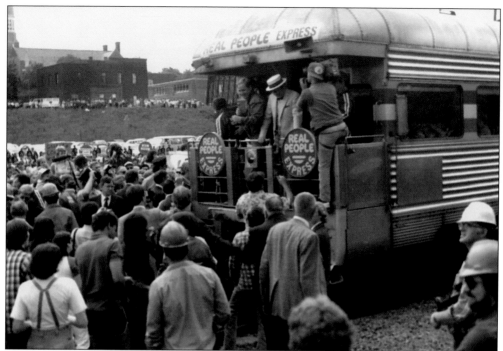

The popular television newsmagazine *Real People* sponsored a cross-country train that drew large crowds at all stops. The show's crew entertained a large throng of fans at the station on May 24, 1983. Political comedian Mark Russell, wearing the straw boater, cracked jokes from the rear platform for the amusement of onlookers during the stop. (Photograph by Jim Shaughnessy.)

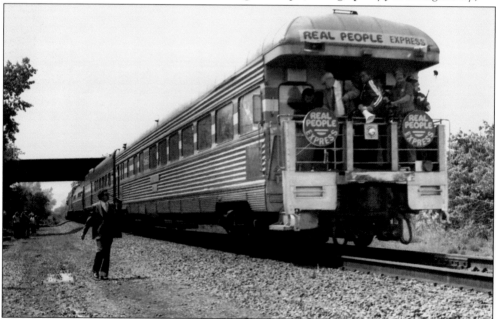

The Real People Express is seen here leaving Rensselaer. The train is accelerating out the old Boston and Albany line, headed for its New England destinations. (Photograph by Jim Shaughnessy.)

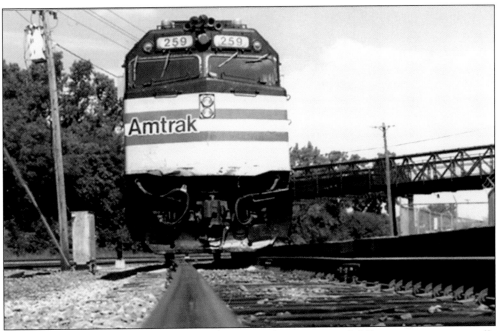

One of the rugged and dependable F-40s waits on the Boston and Albany main to eventually be backed onto train 448, the New England section of the *Lake Shore Limited*. This view of the 259 is from June 1986. (Photograph by Ernie Mann.)

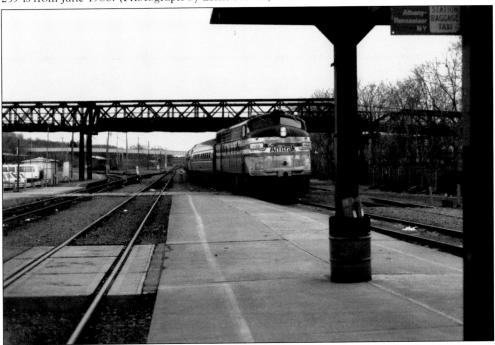

Amtrak locomotive No. 489, one of the venerable FL-9s, built by EMD for the New Haven Railroad in the 1950s, brings an Empire Service train in from New York. The late fall day is gloomy; the Herrick Street Bridge has already been condemned, and the 489 looks much the worse for wear in this scene from the early 1980s. (Photograph by Ernie Mann.)

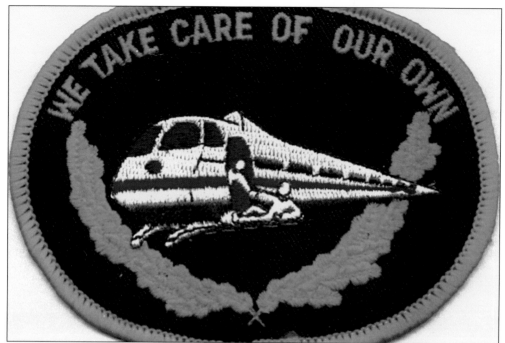

Railroaders have always valued a kinship or brotherhood with each other that was not usually seen in other walks of life. Years ago, a fund-raising effort was initiated for an Amtrak employee who was critically ill. A Rensselaer Amtrak employee designed this patch, which was used on baseball caps sold for the cause. The image of the crewman on a Turboliner helping to pick up a fallen brother symbolized the tradition of railroaders assisting each other in hard times. (Author's collection.)

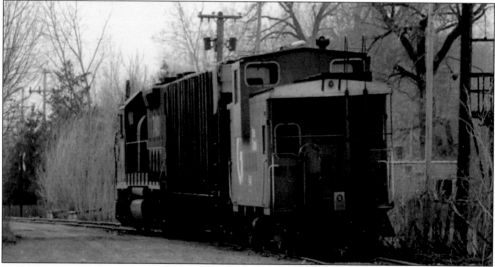

Delaware and Hudson's local freight SC-1 is seen approaching Central Avenue crossing in Rensselaer. The train is returning to Albany after leaving a few cars in Troy. The lonely Troy and Greenbush Railroad line has been threatened with abandonment many times, but survives to this day, used by CSX and Canadian Pacific. The date of this scene is November 8, 1987. (Photograph by author.)

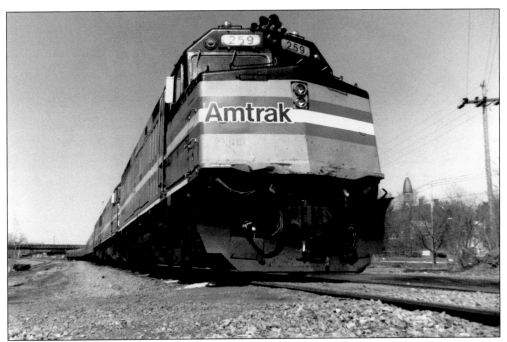

Trains leaving Rensselaer for a run over the old Boston and Albany faced a near-unbroken 58 miles uphill over the west slope of the Berkshires. On this clear, fall day in 1990, the Boston section of the *Lake Shore Limited* begins this climb with two EMD F-40s "on the point." (Photograph by Ernie Mann.)

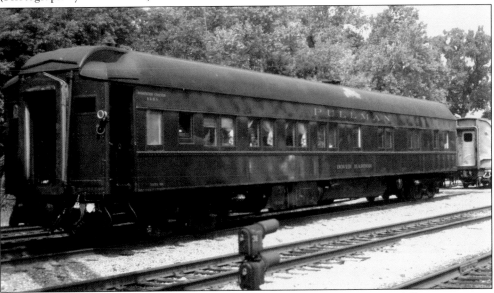

The *Dover Harbor* is one of the few unmodified heavyweight Pullman cars fully operating on American main lines. It was built in 1923 and rebuilt in 1934 to its current configuration. The car ran on the *Broadway Limited*, *Spirit of St. Louis*, *Lake Shore Limited*, and *Commodore Vanderbilt* among others. The Washington, D.C., Chapter of the National Railway Historical Society, which owns the car, has rented it out to racing enthusiasts for a day at Saratoga in this August 8, 1992, view at the depot. (Photograph by Ernie Mann.)

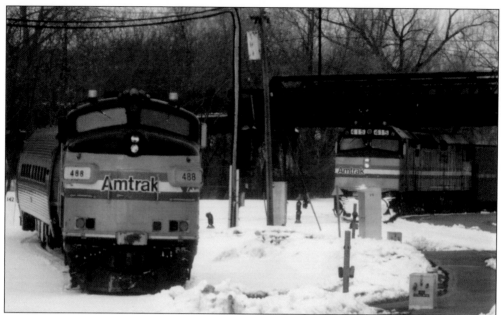

FL-9 488 pauses with a coach on track 17 in Rensselaer yard before hooking up with the New York section of the *Lake Shore Limited*. The Boston section, with two F-40s prepares to swing on the Boston and Albany main line and start its eastward run. The train from Chicago was split into two sections at Rensselaer. (Photograph by Ernie Mann.)

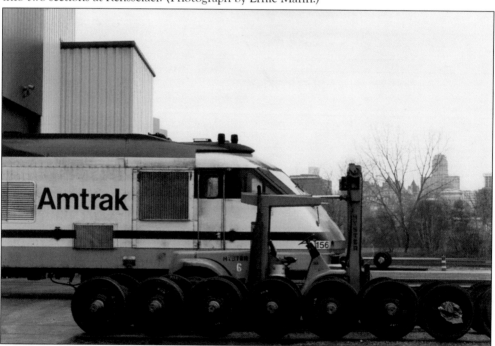

The new Rensselaer Turbo Maintenance Facility was literally the center of the turbo universe. These trains rolled across the Empire State daily at speeds up to 110 miles per hour. The new plant was where routine and heavy maintenance and repairs were performed. These were the only units of their type in the world. (Photograph by Ernie Mann.)

Electro-Motive Division of General Motors came up with the "bulldog" nose design in the 1930s. Many classes of freight and passenger locomotives exhibited this face for over seven decades. One of the last iconic examples is this FL-9 unit shown at Rensselaer after periodic out-shopping. These units were built in the 1950s for the New Haven Railroad. They were unique in their ability to run as straight electric in Park Avenue Tunnel. Amtrak maintained its small fleet of these units at Rensselaer. (Photograph by Ernie Mann.)

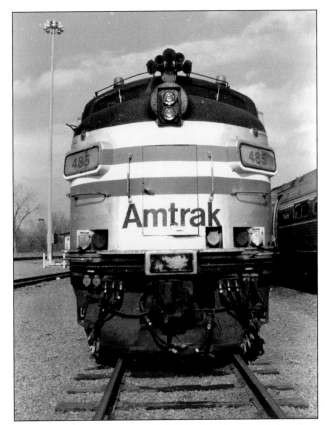

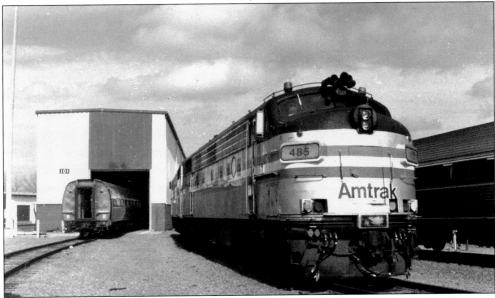

At the Rensselaer maintenance facility, building 101 is the wheel-turning shop where flat spots and other wheel imperfections are ground off with great precision. Seen here is an Amfleet coach in for this work. The pair of FL-9s are finished with their work and ready for their next run. (Photograph by Ernie Mann.)

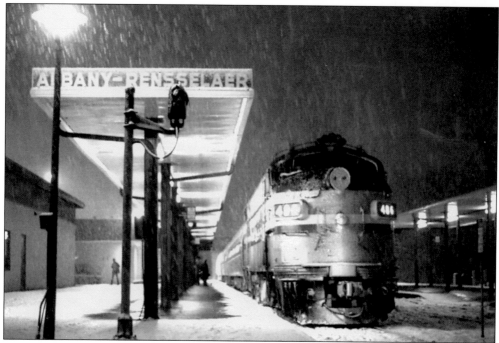

This late-night scene dates to January 1987. Amtrak's FL-9 486 has completed its run from New York to Albany-Rensselaer. In the early hours of the following morning, the train will be cleaned, serviced, and turned on the wye for a morning dash back down the Hudson. (Photograph by Ernie Mann.)

"Safety is of the first importance in the discharge of duty" or a similar admonition is the first notice in virtually every railroad book of rules. Employees at the Rensselaer shop erected this reminder in 1987. (Photograph by Ernie Mann.)

This view from around 1980 features F-40 PH 315 posing with the national and company colors at the locomotive shop. (Photograph by Ernie Mann.)

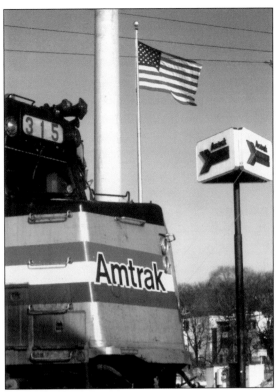

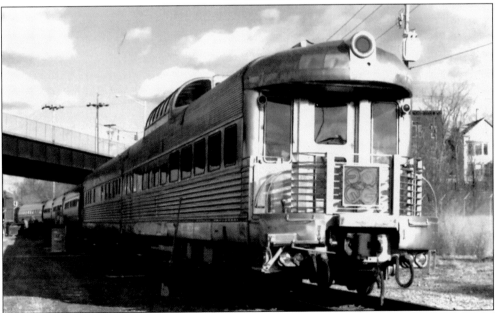

The *Silver Chalet* was originally a Western Pacific dormitory-buffet-lounge. It was acquired by the Chicago, Burlington and Quincy and ran on the legendary *California Zephyr*. It was eventually purchased by Quad Graphics Company and heavily modified with a round end and open platform. It was on a company business trip when photographed at Rensselaer on December 28, 1988. (Photograph by Ernie Mann.)

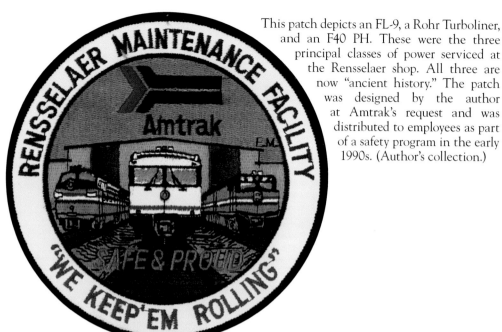

This patch depicts an FL-9, a Rohr Turboliner, and an F40 PH. These were the three principal classes of power serviced at the Rensselaer shop. All three are now "ancient history." The patch was designed by the author at Amtrak's request and was distributed to employees as part of a safety program in the early 1990s. (Author's collection.)

The station and tracks at Rensselaer are heavily shrouded in a winter fog as Amtrak train 69, the *Adirondack*, receives its passengers for a run up the Delaware and Hudson to Montreal. Today's train is a Rohr Turboliner set. Later on, the oversize windows of the Turboliners will be appreciated as the train rolls along scenic Lake Champlain. It is four days after Christmas in this 1993 scene. (Photograph by Ernie Mann.)

Amtrak train 264, the *Henrik Hudson*, is viewed from the warmth of the station interior as it awaits its 4:10 p.m. departure to New York City. Amtrak insisted on using this incorrect spelling of Henry Hudson's name. It is a few days after Christmas in 1993, and the ground is free of snow. (Photograph by Ernie Mann.)

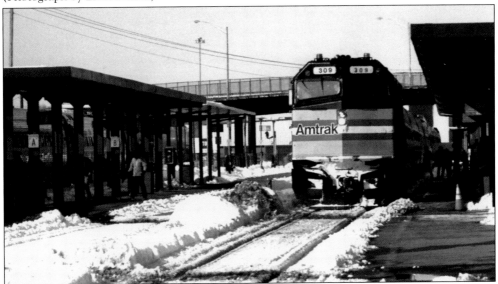

Amtrak train 286, the *Empire State Express*, has just arrived at Rensselaer on March 15, 1993. On the previous day, a blizzard dropped 26.5 inches of snow, much of which melted in the following 24 hours. All trains were very crowded for several days. F-40 309 will be taken off by the yard switcher, and an FL-9 will be coupled on for the final leg of the trip into New York's Penn Station. (Photograph by Ernie Mann.)

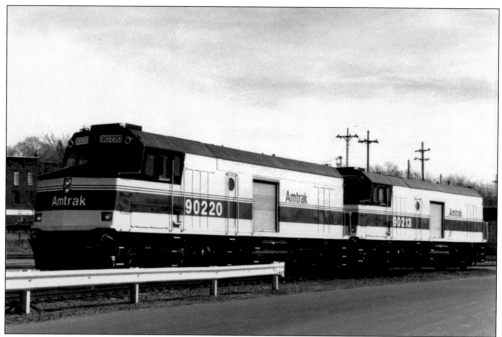

In the mid-1990s, Amtrak removed the prime movers from several EMD F-40s and created non-powered, cab control baggage cars. They were given the nickname "cabbages"—a contraction of cab and baggage. The units were used on push-pull trains. The pair shown here has just been serviced at the Rensselaer shops. (Photograph by Ernie Mann.)

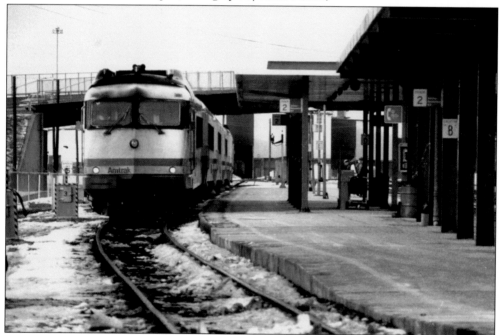

On this March 1993 day, an Amtrak RTG turboliner set drifts through the depot. These rebuilt French turboliners were made to look like their American-built Rohr counterparts, except that they had a noticeable dip at the front end. (Photograph by Ernie Mann.)

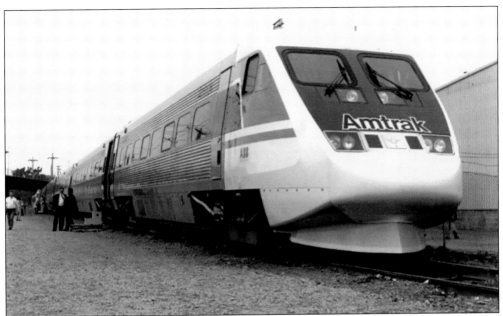

The Swedish State Railway's X2000 was a highly touted example of possible high-speed American passenger service. In 1993, Amtrak sent this train set on a publicity tour around the country. It was notable for its tilt technology, which is computer-driven and anticipates curves at high speed and causes the train to tilt appropriately. Being an electric locomotive, it had to be pulled by diesel power in most areas. The train made a round-trip for publicity from Rensselaer to Penn Station. (Photograph by Ernie Mann.)

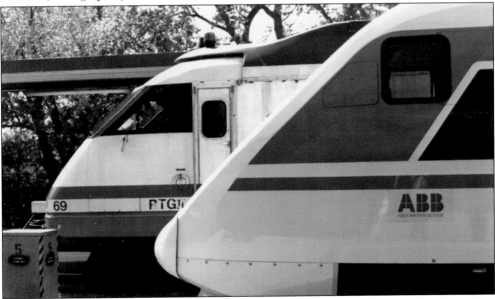

The inspired curves of industrial designers are up for comparison in this photograph at Rensselaer in 1993. Amtrak's RTG turboliner 69 is flanked by the X2000 of Swedish State Railway. The turbo is ready to depart for an afternoon run to New York. The X2000 has just completed a round-trip for politicians and press between Albany-Rensselaer and New York City while on its nationwide tour. (Photograph by Ernie Mann.)

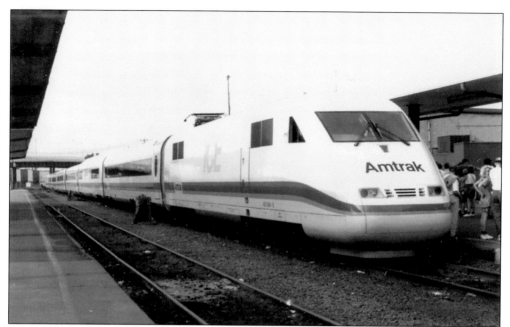

The Intercity-Express (ICE) train of German Railways (Deutsch Bahn) makes a publicity stop at Albany-Rensselaer station on August 11, 1993. Amtrak, again trying to spur interest in high-speed rail, ran the ICE train on a nationwide tour. Like the previous effort with the Swedish X2000, a diesel locomotive had to tow the European train around due to it being electric power. (Photograph by Ernie Mann.)

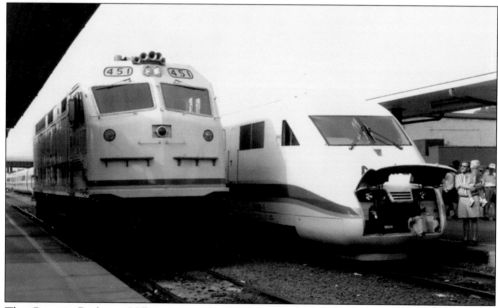

The German Railways ICE train was sent on a nationwide tour by Amtrak in 1993 to spur interest in high-speed rail. Being electric, the train needed diesel locomotives in non-electrified territory. Amtrak painted F-69 PH AC 451 to match the visiting train set. The nose of the ICE train is shown open for routine maintenance on its Rensselaer stop. (Photograph by Ernie Mann.)

The "old order changeth" seems an appropriate adage here. The classic EMD FL-9 contrasts with the new Rohr Turboliner while both are serviced at Rensselaer in this scene from the late 1980s. Both are gone from the scene today. (Photograph by Ernie Mann.)

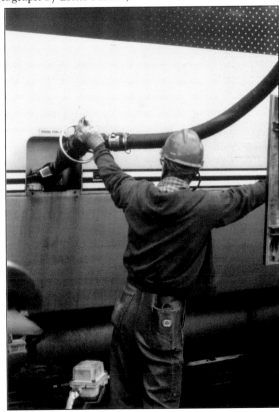

Amtrak's Genesis P40B 817 is brand new and is being fueled by employee Tom Bridgeford at the Rensselaer shop. (Photograph by Ernie Mann.)

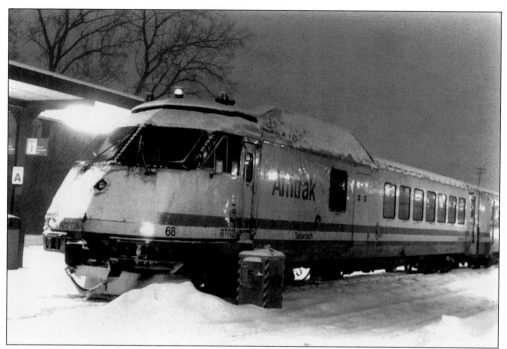

On a below-zero night in January 1994, Amtrak train 265, the *Catskill*, has completed its New York-to-Rensselaer run and awaits a move to the nearby shops for servicing. This train set is a French-built RTG II. (Photograph by Ernie Mann.)

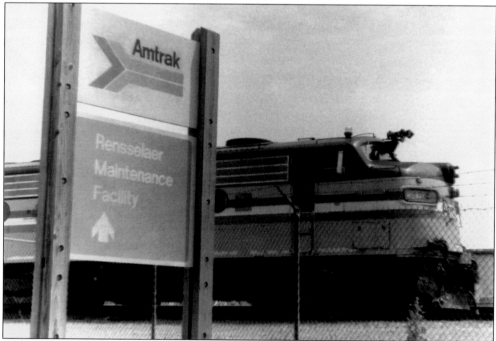

On a beastly hot August day in 1995, Amtrak's queenly FL-9 484 passes the Rensselaer Maintenance Facility sign as it prepares for another fast trip down the Hudson to New York City. (Photograph by Ernie Mann.)

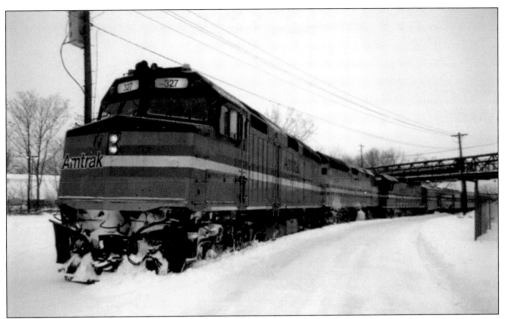

Train 448, the Boston section of the *Lake Shore Limited* from Chicago departs Rensselaer on this December 1995 day for a run over the snow-covered Berkshires. (Photograph by Ernie Mann.)

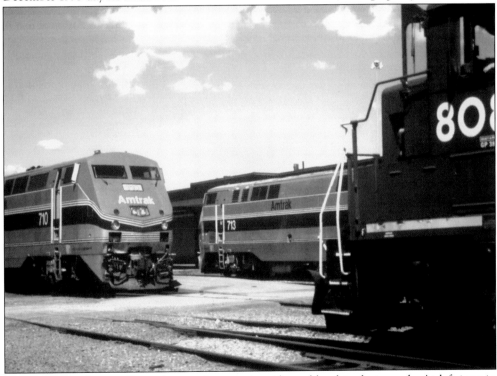

It can get quite busy at Rensselaer at times, as is evidenced by this photograph. At left is train 286, the *Empire State Express*, waiting to embark on the final leg of its Niagara Falls-to-New York run. At center, train 281 arrives from the New York City. At right is Conrail's local freight WASS-11. This scene is from 1998. (Photograph by Ernie Mann.)

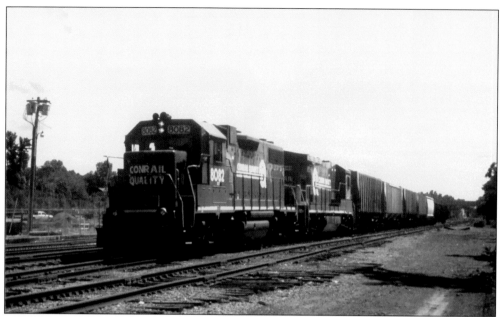

Conrail's local freight WASS-11 pauses at Rensselaer while waiting for track clearance through the station. The train will then return to West Albany after having performed switching at Castleton, the port of Rensselaer, and Rensselaer yard. The scene was recorded on a perfect summer day in 1998. (Photograph by Ernie Mann.)

There has always been something compelling about nighttime passenger trains. On a hot July night in 1999, the power, in this case two Genesis units, for train 49, the *Lake Shore Limited*, to Chicago, is being readied. These units are replacing those that brought the Boston and New York sections to Rensselaer. They will shortly take the *Lake Shore Limited* west. (Photograph by Ernie Mann.)

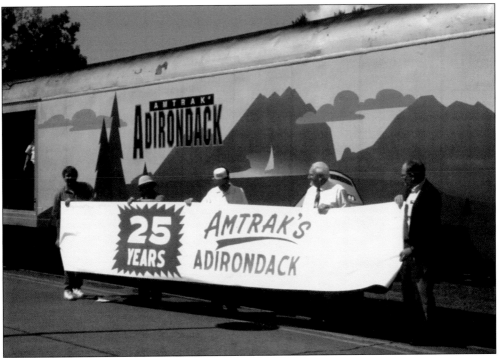

When Amtrak's train 69, the *Adirondack*, arrived from New York on August 5, 1999, members of the Mohawk and Hudson Chapter of the National Railway Historical Society were on hand to commemorate the train's 25th anniversary. The colorful *Adirondack* baggage car was dedicated to this New York-Montreal service for years and was a nice touch appreciated by railfans. (Photograph by Ernie Mann.)

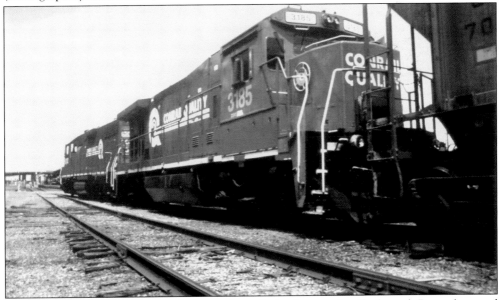

CSX local freight WASS-11 has clearance through the depot as it rolls through Rensselaer yard on its way to South Schenectady, where the crew will "tie up." The two units are still in Conrail paint but sport new CSX numbers on this August 1999 day. (Photograph by Ernie Mann.)

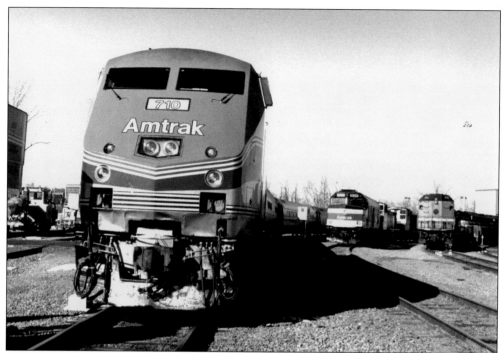

Amtrak's Genesis P-32AC units have dual-power capability and can run as pure electrics in New York City electrified territory. Here, 710 is shown with coaches ready for a fast run down the Hudson Valley. Older F-40 units are at right, awaiting assignments. (Photograph by Ernie Mann.)

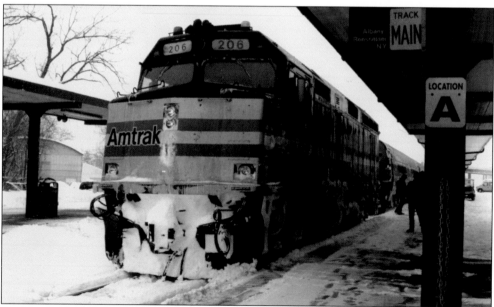

On March 6, 2001, Amtrak train 284 has just arrived at Rensselaer carrying evidence of heavy Mohawk Valley snow. The train has completed two-thirds of its Niagara Falls-to-New York City run. In a little over a year, this station will be replaced with a much larger one. (Photograph by Ernie Mann.)

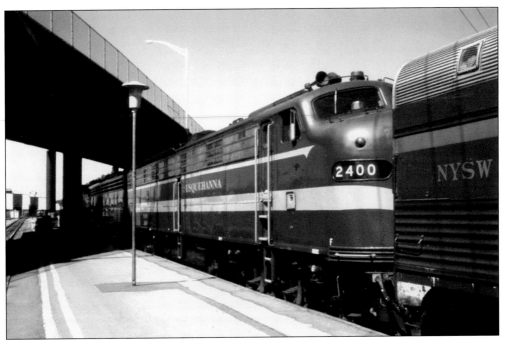

The New York, Susquehanna and Western Railway is a vibrant regional line with routes in New York and New Jersey. The road's late president Walter Rich was himself a railfan as well as a skilled executive. On May 23, 2002, his office car special was at Rensselaer for business meetings. Two beautiful E-8s, 2402 and 2400, provided the power. (Photograph by Ernie Mann.)

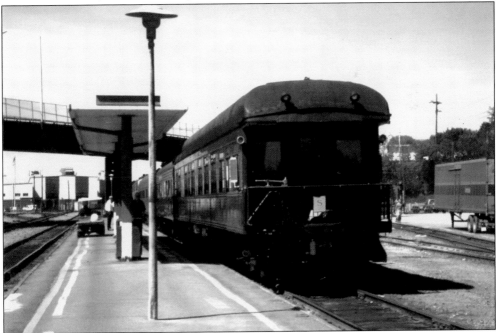

Rich's private car is shown at the rear of a business special at Rensselaer in May 2002. The car was former Rock Island open-end observation 510. The small Susquehanna tail-end sign adds a retro touch of class. (Photograph by Ernie Mann.)

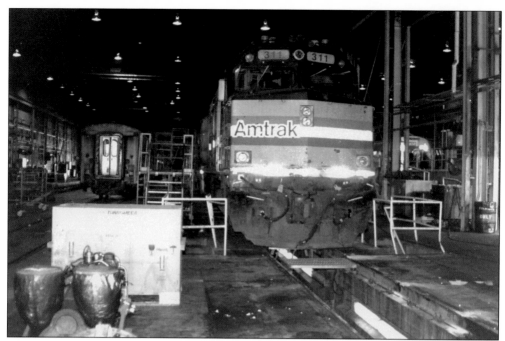

A major part of Rensselaer's rebirth as an important rail center was the construction of Amtrak's large locomotive maintenance facility in 1976. This interior view shows EMD F-40PH 311 being spotted over one of the plant's drop pits for servicing. (Photograph by Ernie Mann.)

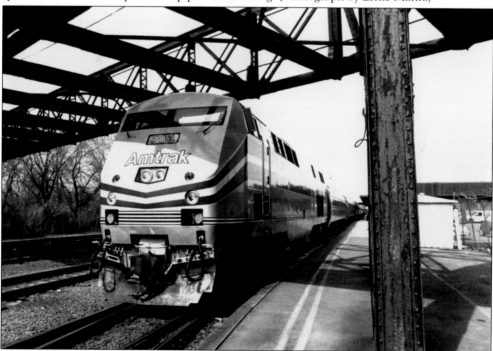

The Herrick Street Bridge of Rensselaer yard dated back to 1892. The bridge was in the process of being demolished in this scene from the late 1990s. A General Electric Genesis unit awaits its late afternoon departure for a run to New York City. (Photograph by Ernie Mann.)

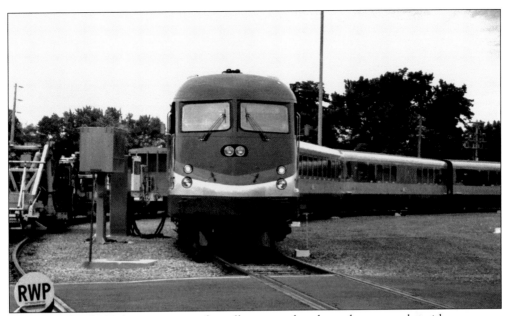

The original Rohr Turbotrain sets ran for well over two decades and were popular with passengers on the Empire Corridor due to their speed (frequently running at 110 miles per hour) and their large windows. They were eventually taken out of service and completely rebuilt at Super Steel in Glenville. Due to a policy and funding dispute with the State of New York, they never resumed full service. This set was at the Rensselaer shop on September 1, 2002. (Photograph by Ernie Mann.)

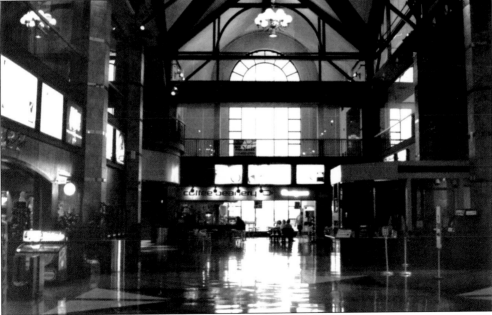

The third, and by far the largest, Albany-Rensselaer railroad station is a beautiful and comfortable throwback to the great big-city stations of the mid-20th century. In the last few years, an average of 775,000 passengers annually have used the facility. It is considered the 10th busiest in the United States. (Photograph by Ernie Mann.)

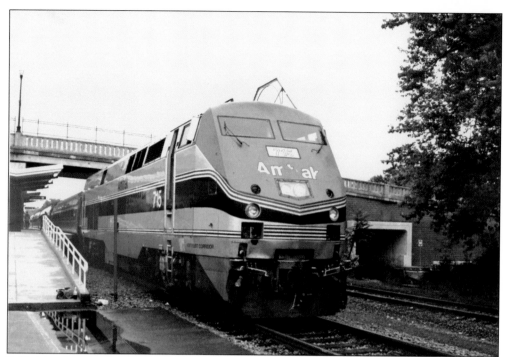

Pulled by Genesis P-32AC 715, the first northbound train from New York arrives at the new Albany-Rensselaer station. The date was September 21, 2002. Part of the station project was the new Herrick Street Bridge, seen in the background. (Photograph by Ernie Mann.)

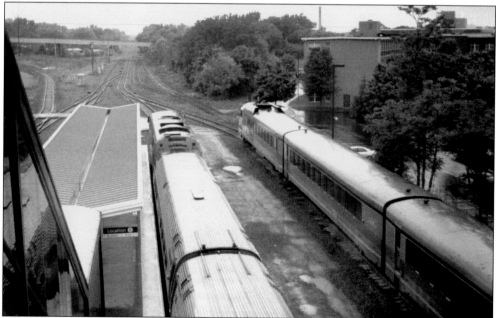

The new Amtrak-CDTA Rensselaer station offers a magnificent viewing area for passengers awaiting their trains. In this southward view, the train at left is ready to depart for New York City. The train on the right is one of the ill-starred rebuilt turboliner sets that never saw much revenue service. (Photograph by Ernie Mann.)

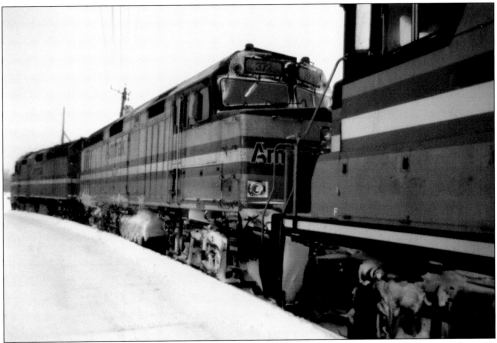

The Boston section of the *Lake Shore Limited* begins its assault on the Berkshires on a bitterly cold winter day. Trains headed out on the Boston and Albany begin climbing before they leave Rensselaer yard. (Photograph by Ernie Mann.)

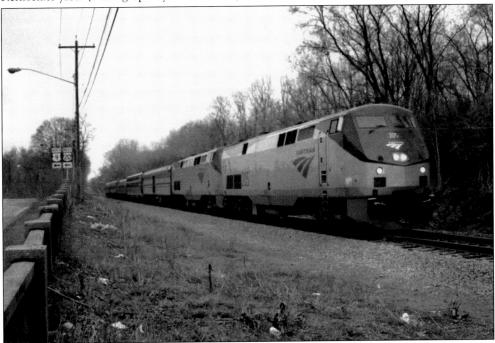

Amtrak train 448, the Boston section of the *Lake Shore Limited*, has just departed Albany-Rensselaer and is about to duck under Routes 9 and 20. The train will have a tough climb ahead until it crests the Berkshires at Washington, Massachusetts. (Photograph by Ernie Mann.)

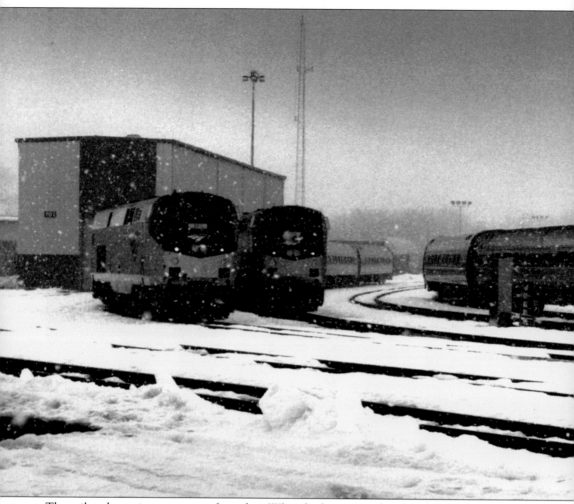

The railroads run in every type of weather. When highways are closed and flights are grounded, the trains, albeit a few hours late, still run. Generations of railroaders in Rensselaer made sure of this, whether the day presented sweltering heat or bitter cold. Just out from the shop, these hardy Amtrak units await their next assignments. (Photograph by Ernie Mann.)

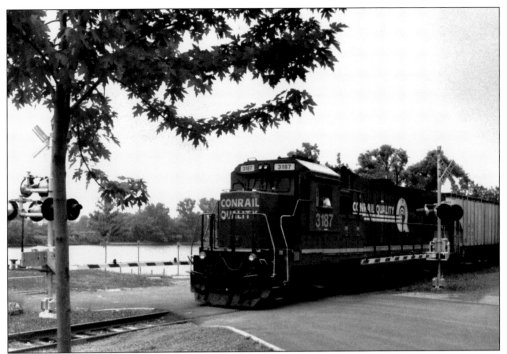

CSX local freight B-761 passes the boat launch off Forbes Road in Rensselaer. Now officially the Troy Industrial Track, the line is the original Troy and Greenbush Railroad dating back to 1845. (Photograph by Ernie Mann.)

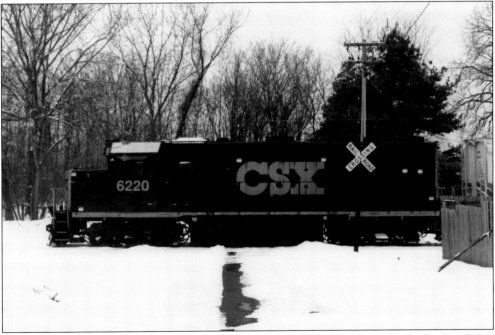

Returning from Troy and headed for South Schenectady, CSX local freight B-761 is seen at Tracy Street crossing in the throes of a bleak winter day. (Photograph by Ernie Mann.)

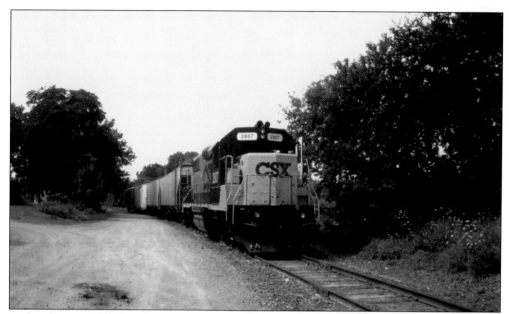

Railroaders just called it the Troy Branch, but the original Troy and Greenbush Railroad has had a long history, dating to 1845. This bucolic scene, just off Forbes Road, belies the line's past prominence. Decades ago, the branch was double-tracked with semaphore signals and saw the daily passage of New York Central and Delaware and Hudson passenger trains. Today the line is still used by CSX and Canadian Pacific. (Photograph by Ernie Mann.)

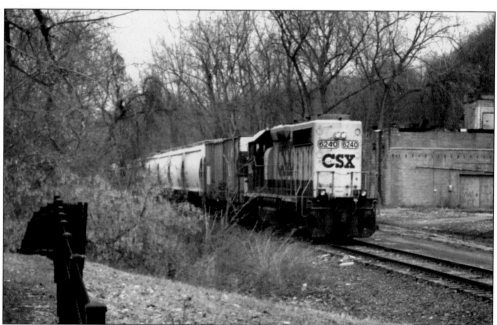

The historic Troy and Greenbush Railroad remains in use today as CSX's Troy Industrial Track. Here, the thrice-weekly local B-761 returns to Rensselaer from Troy with empty cars used for grain traffic. This branch has seen some increased business in recent years, and the roadbed has been upgraded accordingly. (Photograph by Ernie Mann.)

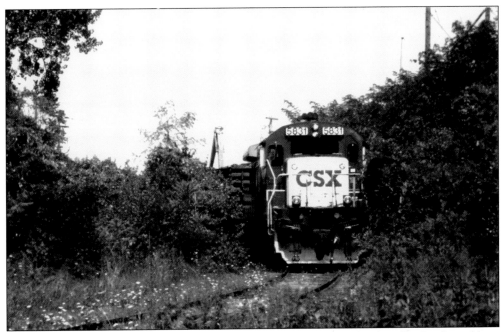

Not all of Rensselaer's tracks were highly polished by incessant wheel traffic. Looking like a rural short line is the Port branch into the Rensselaer Iron and Steel Company. Here, CSX local freight B-761 carefully retrieves a few cars of scrap metal. (Photograph by Ernie Mann.)

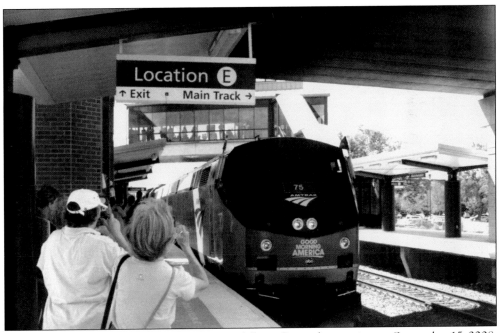

ABC's *Good Morning America* train arrives at Albany-Rensselaer station on September 15, 2008. This was one of the first stops on the train's tour. An enthusiastic crowd was on hand to greet the show's celebrities. The original train had been assembled at the Rensselaer locomotive facility. (Photograph by Ernie Mann.)

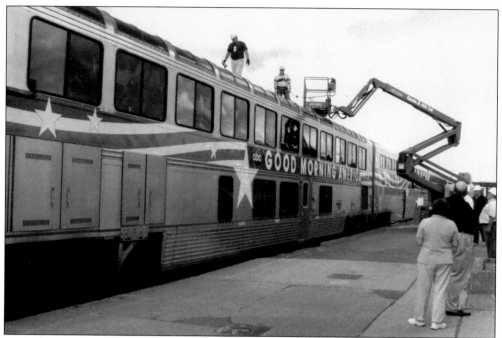

ABC's *Good Morning America* train is being serviced at Rensselaer in preparation for its trip west. The equipment used in this train had originally been assembled and decorated by Rensselaer's shop forces before its itinerary had begun. (Photograph by Ernie Mann.)

On September 15, 2008, the *Good Morning America* train leaves Rensselaer on the next leg of its run through eastern states as part of the show's "50 States in 50 Days" production, which hoped to take the country's pre-election pulse and identify voter's concerns. Bringing up the rear is ex–Pennsylvania Railroad car 120. The road's presidents used this car. It also served Presidents Franklin Roosevelt to John F. Kennedy, and carried Robert Kennedy's casket. (Photograph by Ernie Mann.)